IMAGES
of America

EDISON

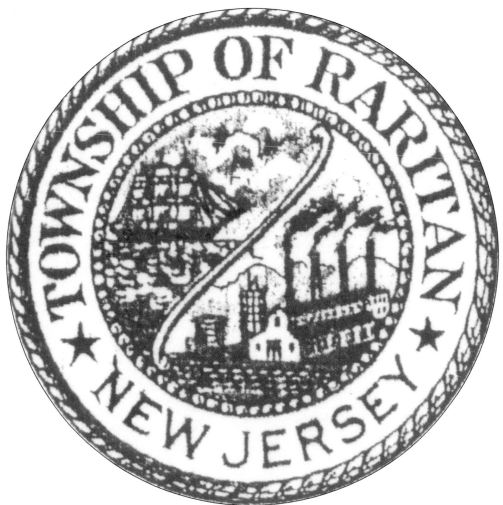

Raritan Township was officially renamed Edison Township on November 10, 1954. Until then, when asked where they lived, people would respond with Bonhamtown or Oak Tree, for example, but not Raritan Township. In addition, no Raritan Township post office existed. Rather, the Metuchen, Nixon, Stelton, Rahway, and Woodbridge post offices served the township. In response, efforts began in the 1950s to provide the township with a new name to reflect its new identity as a growing suburban community. Mrs. Charles Wira and her group, Women of Edison, convinced residents of the need for a name change to commemorate the township's most famous resident, Thomas Alva Edison. A referendum was placed on the November 2, 1954 general election ballot and, with a vote of 3,723 for and 3,075 against, the name was changed.

IMAGES
of America

EDISON

Stacy E. Spies

ARCADIA
PUBLISHING

For ADS, who supports me in all my endeavors.

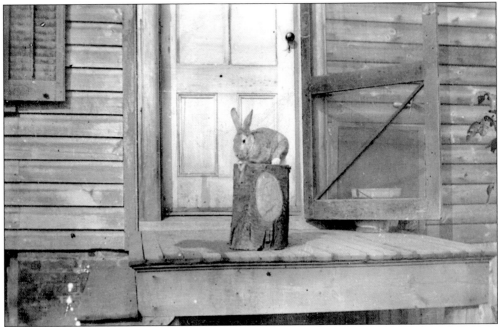

Family photographs are the most endearing components of the collection of the Metuchen-Edison Historical Society. Teenager Charles End posed the family's pet rabbit on the kitchen porch, c. 1908–1910. Mr. End found the negative for this photograph in a box in his garage in 1982.

CONTENTS

ACKNOWLEDGMENTS

This project was the result of heads, hearts, and hands working together to present the most interesting images in the collection of the Metuchen-Edison Historical Society. The society's extensive collection is lovingly cared for by its curators. It is through their labors, begun long before this book came to be, that I had access to hundreds of photographs and research materials. This work is richer for their efforts.

There is one person in particular without whose support I could not have completed this book: Edison resident Marie Vajo. Her effort is apparent in the depth of the society's collection.

The contributions of several persons who volunteered time, information, and photographs have made this book more thorough than it would have been otherwise. My sincere thanks go to several people who aided the compilation of this book: Keith Cullum, director of the Kiddie Keep-Well Camp, for sharing with me the history of the camp; Jim Halpin and Rita Halpin for sharing their photographs; Daniel Januseski, Joseph Katz, and Mike Petercsak of Edison First Aid Squad No. 2 for loaning photographs and providing me with historical information on the squad; Jeanne Kolva for her ingenuity in seeking out photographs and information and for the loan of photographs; Douglas Petersen for sharing the photograph he took of *Light Dispelling Darkness* (this small format does not do justice to his beautiful photographs); Tyreen Reuter for helping me with digital images; Walter Stochel Jr., historical society president, for sharing with me his wealth of information about Edison's history and his photographs of Oak Tree; Doug Tarr, archivist at Edison National Historic Site, West Orange, New Jersey, for his assistance; and Ray Vliet, for sharing his photographs and his extensive knowledge of Raritan Engine Company No. 1.

Most importantly, my thanks go to the many residents, past and present, who entrusted their treasured photographs to the society's stewardship. Without their donations of images and information, the society would not have the fine collection it has today.

INTRODUCTION

This book is intended as a celebration of the history of Edison Township and as a sampling of the photographic collection of the Metuchen-Edison Historical Society. I hope that you will see something of yourselves in the familiar faces and settings and will learn about places and people that are gone.

Edison Township was named for its most famous citizen, inventor Thomas Alva Edison. The municipality began as Raritan Township, which was formed from parts of Piscataway Township and Woodbridge Township in 1870 and included what are now the independent boroughs of Highland Park and Metuchen. The township consisted of small hamlets and clusters of buildings near railroad stops separated by farm fields. All that remains of some of these communities and residents are familiar place names, such as Fords, Stelle (Stelton), Bonham, Talmadge, Tingley, Nixon, and Lindeneau.

The first European-born settlers arrived during the 17th century. Fertile soils and access to the navigable Raritan River made this an attractive location to the Lenni Lenape people already living here and to the settlers who made their homes in Piscatawaytown, Bonhamtown, and Metuchen. The first settlers arrived in 1665, having traveled with Sir George Carteret from New England. Others soon followed from Long Island, New Haven, and New England. Baptist church services were under way in 1689 in Piscatawaytown, which also served as the seat of justice for Middlesex and Somerset Counties as early as 1683. The first township school was constructed there in 1694.

Settlements slowly grew during the 18th century, and churches and meetinghouses were constructed. The first meetinghouse was established in Metuchen c. 1715 and, by 1725, Quaker meetings were being held on Woodland Avenue. The original St. James Episcopal Church was constructed in 1724. Travel between settlements was facilitated with the construction of roads. The first survey of Main Street in Metuchen, then known as the Bonhamtown–Oak Tree Road, was undertaken in 1705 to rework an already existing road. Early travelers between New York and Philadelphia followed the post road, which appears on a 1762 map drawn from a 1745 survey and which was the through route used to carry the mail. The post road followed the route of present-day Old Post Road and portions of Woodbridge Avenue. The Middlesex and Essex Turnpike (now Middlesex Avenue/Route 27) was created in 1806 and the Perth Amboy and Bound Brook Turnpike (now Amboy Avenue and New Durham Avenue) in 1808.

The Revolutionary War was fought on township soil. British soldiers camped in Piscatawaytown. Five British regiments were stationed at Bonhamtown, and troops plundered homes and farms. Residents also witnessed the dramatic events of the Battle of Short Hills. Gen. George Washington had come out of the Watchung Mountains to Quibbletown in Piscataway, and on June 26, 1777, some 12,000 British troops marched from Perth Amboy in an attempt to take the gaps in the Watchung Mountains to the north and contain Washington in a pincer movement. American troops under the command of Lord Stirling and the local militia harassed the two columns of British troops as they advanced. One column marched north to Woodbridge and

then turned west along Oak Tree Road. The second column headed west and moved through Metuchen via Main Street and along Plainfield Road. Skirmishes took place near the Oak Tree intersection with Plainfield Avenue and continued through the Short Hills into Scotch Plains. Four days later, the British troops retreated to Perth Amboy and sailed for Philadelphia.

In 1836, the New Jersey Railroad (later the Pennsylvania Railroad) was completed to New Brunswick. Stations were constructed at Menlo Park, Metuchen, and Stelton. At that time, Bonhamtown contained a dozen dwellings, two taverns, a store, and a schoolhouse. Piscatawaytown was of similar size. New Durham consisted of a tavern, a store, and a half dozen dwellings. Uniontown—or Unionville, as Menlo Park was once known—had only a few dwellings, which were near the railroad station. By the end of the 19th century, residents, especially those in Metuchen, began to commute to jobs in New York City. For the most part, however, township residents pursued farming or small industrial pursuits. The largest of these industries was clay mining and brick manufacturing near Bonhamtown.

A whirlwind of activity took place in this slow-moving agricultural township following the arrival of Thomas Alva Edison in 1876 to Menlo Park, where he created what is considered to be the first industrial research laboratory in the United States. While here, the Wizard of Menlo Park invented the phonograph, the electric lightbulb, and obtained more than 400 patents. Edison's successes made the hamlet of Menlo Park known worldwide, and thousands of tourists and visiting scientists arrived via the railroad to see his "invention factory."

Work at the laboratory dwindled by 1882 as Edison became busy implementing his inventions at other locations. After the death of Edison's wife in 1884, the inventor did not return to Menlo Park and left the buildings to deteriorate. Edison remarried in 1886 and constructed a new laboratory and home in West Orange, New Jersey, the following year. In 1928, the ruined laboratory buildings of Menlo Park, which by then had become little more than piles of wood and brick, were carried off by Henry Ford and reconstructed with new materials at his Greenfield Village museum in Dearborn, Michigan.

At the turn of the century, Metuchen was the township's largest community and had become its commercial and social center. Highland Park's proximity to New Brunswick also created a concentration of people in that corner of the township. The differences between these suburbs and the rural character of the remaining township became apparent by 1900, when Metuchen became an independent borough. Highland Park followed suit five years later.

Edison has seen its most dramatic changes during the 20th century. In 1913, the nation's first transcontinental highway, the Lincoln Highway (now Route 27), traversed the township; several interstate highways have since followed its lead. The township's extensive open space began to attract suburbanites in the early decades of the 20th century. In 1920, the township population was just 5,419 persons; however, the population nearly doubled over the next 10 years to 10,025 persons. Abundant open space also prompted the federal government to construct Raritan Arsenal during World War I and Camp Kilmer during World War II.

The most dramatic changes in Edison have occurred as a result of the post–World War II building boom. The township's open space, combined with its proximity to New York City, facilitated the development of numerous postwar residential developments. Between 1950 and 1954, the population increased by nearly 60 percent from 16,348 to about 26,000 persons. Development has continued; the estimated 2000 population was 95,905 persons, a 1,670-percent increase in 80 years.

Nearly all of the photographs in this book are in the collection of the Metuchen-Edison Historical Society. The names of donors, when known, have been included in parenthesis. Photographs loaned expressly for inclusion in this book are so noted in parenthesis with the notation "Courtesy of. . . ." Space constraints and availability limited the choice of images. I encourage the reader to contact the Metuchen-Edison Historical Society with any additional information and photographs that will increase residents' understanding of township history. Any omissions or errors are purely unintentional.

—Stacy E. Spies

One

MENLO PARK

Thomas Alva Edison's laboratory, seen in this view looking north, was in poor condition by the time this 1909 photograph was taken by J. Lloyd Grimstead. After Edison's departure, the buildings steadily deteriorated until 1928, when Henry Ford took what little remained of the buildings to his Greenfield Village museum in Dearborn, Michigan. Ford's crew also salvaged parts of the buildings that had been reused in neighbors' farm structures, and conducted an archeological excavation to locate remnants of the buildings.

This bird's-eye view of Menlo Park looking north from the J.B. Smith estate shows Thomas Edison's complex barely visible in the distance at left, on top of the hill. This vantage point is now probably within the property of the New Jersey Home for Disabled Soldiers on Evergreen Road. In the six years during which Edison's Menlo Park laboratory was active, Edison obtained no fewer than 400 patents, many of which changed the course of modern life. Menlo Park was the site of the invention of the incandescent lightbulb and the electric lighting system, the phonograph, and improvements to the telephone carbon transmitter and to the telegraph system. When Edison arrived in 1876, Menlo Park was a farming community with a small rail station stop on the Pennsylvania Railroad. Menlo Park was chosen because the railroad provided access to resources and labor but lacked the distractions of the city, a feature about which employees sometimes complained. (Courtesy of U.S. Department of the Interior, National Park Service, Edison National Historic Site.)

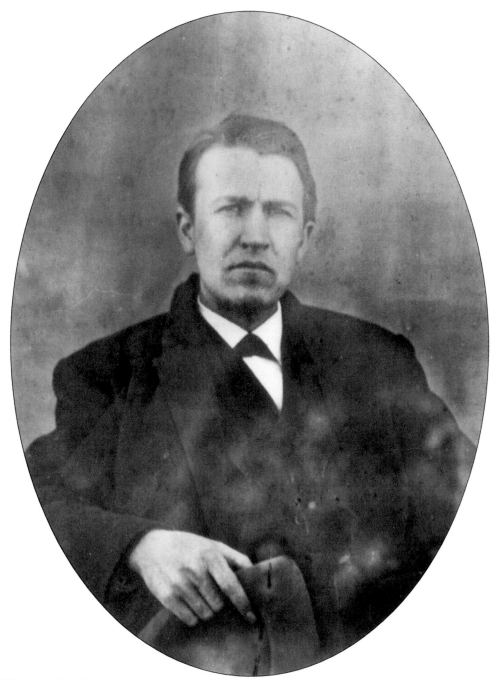

Thomas Alva Edison (1847–1931), seen here in 1879, was born in Milan, Ohio, and grew up in Port Huron, Michigan. During the Civil War, he worked as a telegraph operator and, in 1869, became a full-time inventor, forming his first business manufacturing telegraph equipment in Newark, New Jersey. He patented his first invention at the age of 22 and went on to patent 1,092 more inventions during his lifetime. (Courtesy of U.S. Department of the Interior, National Park Service, Edison National Historic Site.)

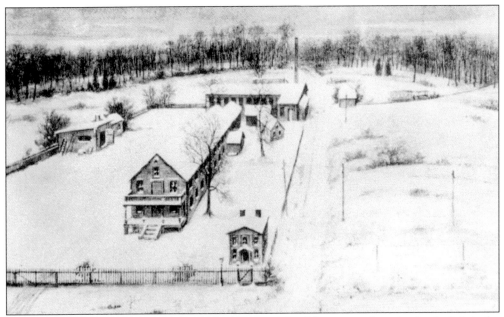

This 1880 painting provides an idea of the layout of the Edison complex. At the far left is the carbon shed. The two-story building in the center is the laboratory, and the machine shop is attached perpendicularly at its rear. The small building in the right foreground is the office and library, which is painted much smaller than it was in real life. Christie Street is to the right of the office. (Courtesy of U.S. Department of the Interior, National Park Service, Edison National Historic Site.)

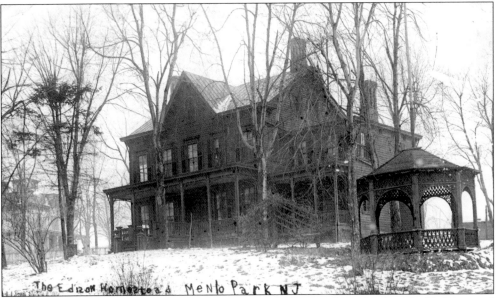

Edison's home was located at the northwest corner of what was later the Lincoln Highway and Christie Street intersection, just two blocks from his laboratory. Edison—with his first wife, Mary, and their children Marion (Dot), Thomas Jr. (Dash), and William—lived here from 1876 until Mary's death in 1884. Fire destroyed the house in 1917. Edison married Mina Miller in 1886, moved to West Orange, and had three additional children: Madeleine, Charles, and Theodore.

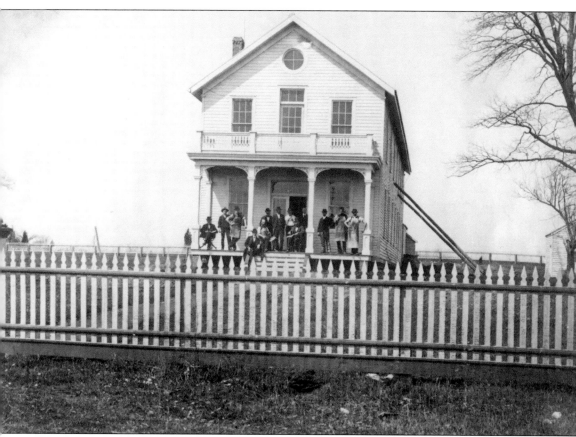

Edison purchased the Menlo Park property from the family of William Carman, one of Edison's employees. In 1876, the wooden laboratory, glass house, carpenter's shop, carbon-production shed, and blacksmith shop were constructed. This c. 1876 photograph shows employees assembled on the laboratory porch. The second floor of the laboratory has been called the "nerve center" of Edison's experimentation. The "talking machine" was the by-product of Edison's attempts to record telegraph signals. He perfected this machine, the phonograph, on December 6, 1877, and the newspapers dubbed him the Wizard of Menlo Park. After the phonograph, Edison was quickly on to new projects, such as the incandescent lightbulb and an electrical lighting system. In 1878, the brick machine shop and the office and library building were constructed in anticipation of tackling these new tasks. The renowned engineering firm of Babcock & Wilcox of New York City designed the machine shop. (Courtesy of U.S. Department of the Interior, National Park Service, Edison National Historic Site.)

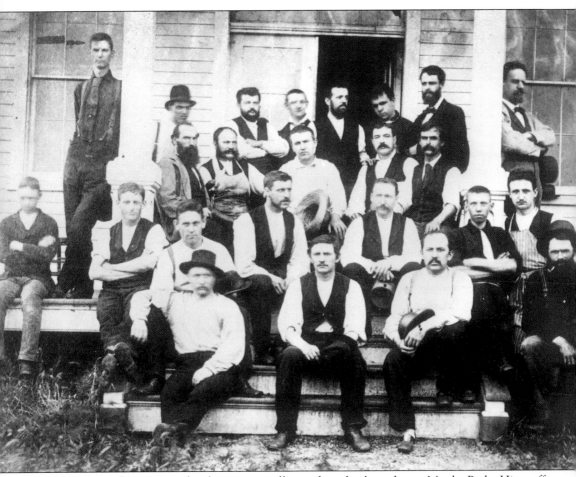

Edison's employees were local men, as well as others he brought to Menlo Park. His staff expanded to as many as 200 workers, depending on the size of the projects. Edison often called them "his boys" and they called him "the old man," even though he was just 29 when he arrived in Menlo Park. Pictured, from left to right, are the following: (first row) Alfred Swanson, Martin Force, Stockton L. Griffin, and William Andrews; (second row) Johnny Randolph, C. Flammer, ? Wright, C. Carman, John F. Ott, James Seymour, and unidentified; (third row) unidentified, ? Cunningham, Thomas Edison, Major F. McLaughlin, and T. Logan; (fourth row, standing) John W. Lawson, George Oram?, Albert Herrick, Ludwig K. Boehm, Charles Batchelor, Francis Jehl, Francis R. Upton, and Dr. Alfred Haid. Among the key players were Batchelor (an Englishman who served as Edison's chief mechanical assistant), Boehm (a German glassblower), John Kreusi (a Swiss clockmaker), Upton (a mathematician), Samuel Mott (a draftsman for patent drawings), and Grosvenor Lowery (Edison's lawyer and fundraiser). (Courtesy of U.S. Department of the Interior, National Park Service, Edison National Historic Site.)

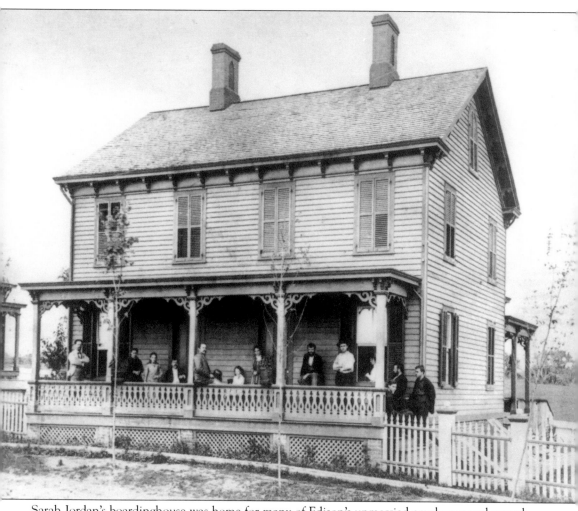

Sarah Jordan's boardinghouse was home for many of Edison's unmarried employees and served as a social center for all of the employees and their families. Jordan, an old friend and distant relative of Edison, was widowed in 1877. Realizing that his employees needed housing and that Jordan needed income, Edison brought her from Newark to set up a boardinghouse. Jordan, her daughter Ida, and their servant Kate Williams attended to the boarders. Pictured, from left to right, are Alfred Haid, Sarah Jordan, her daughter Ida, Major McLaughlin, an unidentified man on the railing, Mrs. Van Cleve, her daughter Francis Upton, Thomas Edison, an unidentified woman in the window, an unidentified man, Francis Jehl (standing), and John Lawson (seated on the steps). Located on the north side of Christie Street between Edison's home and the laboratory, the house was one of just two Edison-related buildings taken to Greenfield Village, where it was restored and can be visited today. All of the other buildings had fallen down and had been scavenged for parts or moved. Those buildings were reconstructed with new materials in Dearborn. (Courtesy of U.S. Department of the Interior, National Park Service, Edison National Historic Site.)

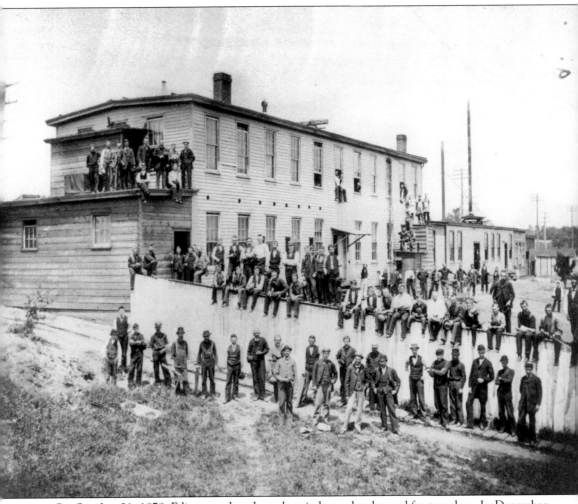

On October 21, 1879, Edison produced an electric lamp that burned for two days. In December of that year, he made a public demonstration when lamps were installed in the neighborhood around the laboratory, much to the delight of the crowds that came to see this wonder. An even bigger display would happen three years later. On September 4, 1882, the Pearl Street Station in New York City began commercial distribution of electricity for light and power through a system designed by Edison. Hundreds of incandescent lights were lit that night in the financial district. The Edison Lamp Works, pictured here, was established in 1880 for the manufacture of incandescent lamps to support the application of this new invention. The factory was located on the southeast side of the railroad and the Lincoln Highway, across from Phillip Street and Cedar Street. Among the local men who worked there were William and John Trumbull. (Courtesy of U.S. Department of the Interior, National Park Service, Edison National Historic Site.)

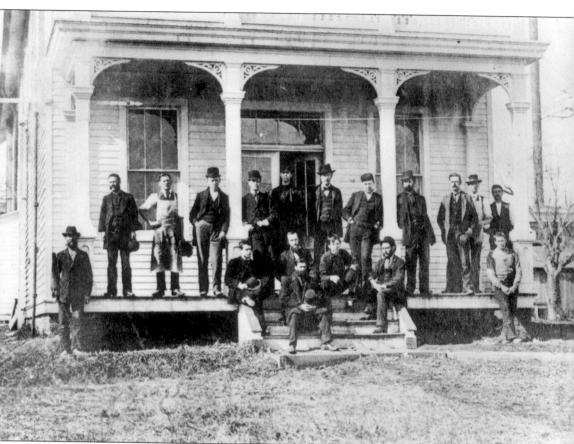

The laboratory staff steps out onto the porch c. 1880. The only man identified is Edison, who is leaning against the second porch column from the right, with his hands in his pockets. Edison's success is due not only to his creative genius but also to his ability to bring in talented individuals who could turn his ideas into physical realities. These men had particular skills, financial resources, or access to scientific equipment and materials. Edison worked long hours alongside his staff, trying one permutation of the invention after another. In this spirit, Edison good-naturedly called his workers "muckers," among whom he was the "chief mucker." The typical workweek consisted of six 10-hour days, with work stretching long into the night if a breakthrough was near. The diverse talents of the staff aided the experimentation process. Among the staff were John Lawson (an assayist who came to Edison for his training), Alfred Haid (a chemist), and laboratory assistants Martin Force and Francis Jehl. Jehl became the first caretaker of the Greenfield Village reconstruction. (Courtesy of U.S. Department of the Interior, National Park Service, Edison National Historic Site.)

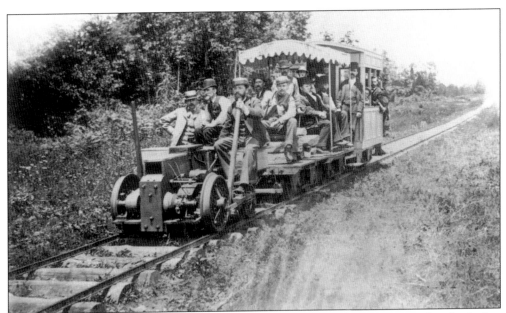

Edison invented an electric railroad, requiring no conductors or engineers, decades before electric trains became common. Edison and his assistants, seen here, first traveled the one-third-mile track on May 13, 1880. The line was extended in 1882 to connect Menlo Park and Dark Lane (Grove Avenue), and though successful, its potential was never fully realized. (Courtesy of U.S. Department of the Interior, National Park Service, Edison National Historic Site.)

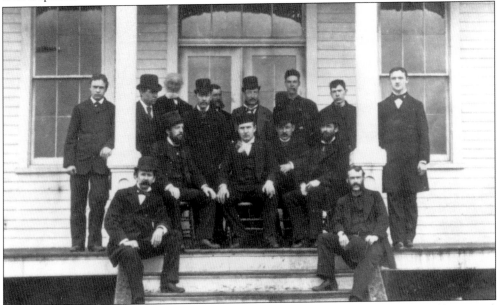

Pictured on the laboratory porch c. 1880 are, from left to right, the following: (front row) William Holzer and James Hipple; (middle row) Charles Batchelor, Thomas Edison, Charles Hughes, and William Carman; (back row) Albert Herrick, Francis Jehl, Samuel Edison (father of the inventor), George Crosby, George Carman, Charles Mott, John Lawson, George Hill, and Ludwig Boehm. (Courtesy of U.S. Department of the Interior, National Park Service, Edison National Historic Site.)

Even though Edison's laboratory moved to West Orange in 1887, the Edison Lamp Works stayed in the area into the 20th century. Edison Lamp Works employees are shown here *c.* 1911 at a chicken roast in Mine Gully, located a mile north of Menlo Park. The name D.T. Marshall, author of *Boyhood Days in Old Metuchen*, is noted on the back of the photograph. Note the man at left holding a large pair of shears.

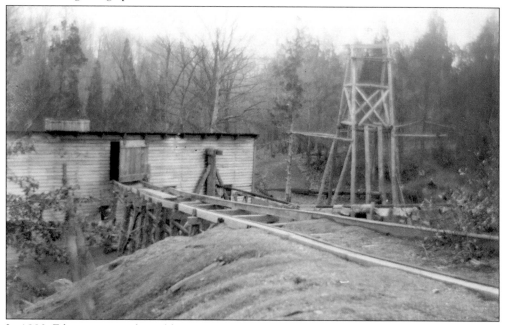

In 1880, Edison reopened an old mine in Mine Gully to provide copper for his experiments and for wire used in incandescent lamps. The pump tower, head house, and railroad siding that were used to carry materials out of the mine are seen here in 1906. The mine was more than 100 feet deep but did not provide sufficient materials and was therefore abandoned.

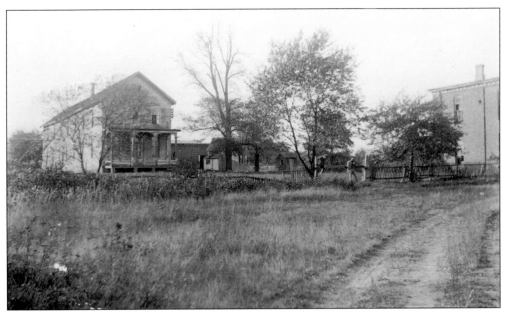

By the time J. Lloyd Grimstead took this photograph in 1911, the Edison complex had been abandoned and was in poor condition. Looking north, the view shows the laboratory at the left and the office at the right. The machine shop and other buildings are visible at the rear. After Edison's departure, the buildings were used as dwellings by several families and later scavenged for building materials. Note the two small figures by the picket fence at the center.

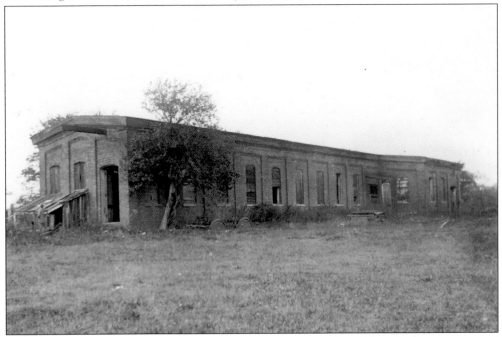

The machine shop, which was looking forlorn by 1911, was where Edison's ideas were turned into realities. John Kruesi, a Swiss-trained master machinist and machine shop foreman, was responsible for figuring out how to manufacture the products that Edison and his assistants invented. Kreusi had followed his employer from the Newark shop.

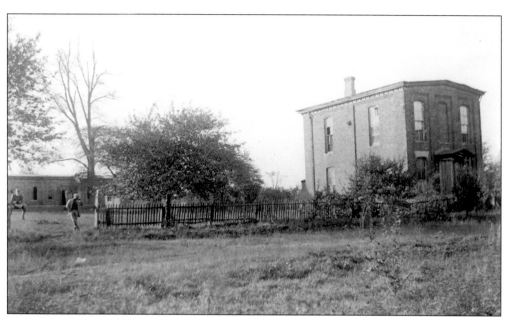

This photograph is a continuation of the view on the opposite page. After Edison's departure, the buildings were put to new uses, none of which were as glamorous as the way they had been used during Edison's tenure. The first floor of the laboratory was used as a cow barn. The office building, seen here at right, had contained offices for Edison and his bookkeepers, and a library was located on the second floor. It later became a residence.

The first successful incandescent lamp was made on site in the glass house, seen here in 1910. The master glass blowers and their assistants made lamp bulbs, glass tubing, and glass implements here for use in the laboratory. Successor company General Electric moved the building to Parsippany and later donated it to Greenfield Village, where it is one of just two original Menlo Park buildings.

Seen here in 1911 in use as a chicken coop, this old horse car body was used as a passenger coach for Edison's electric railway molders beside the carbon shed. (See page 18 for a view of another, earlier version of the passenger coaches.) Kerosene lamps were burned continuously in the shed to provide carbon, which was used to make carbon buttons for telephone transmitters.

In this 1911 Grimstead photograph, one of Edison's locomotives and a railroad car base lie in the weeds beside the machine shop (see page 18). Charles Bloomfield purchased several trucks, coaches, and cars like these from Edison for use at his clay pits. In 1928, Bloomfield offered this equipment to Henry Ford for inclusion in Ford's museum.

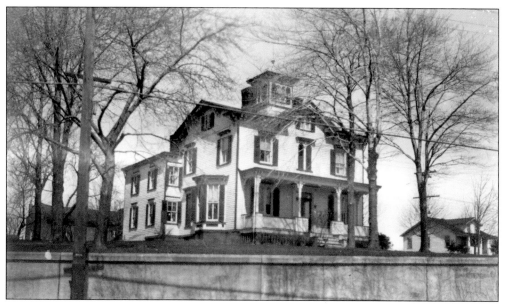

Located at the northwest corner of the Lincoln Highway and Frederick Street, the Thornall house was one of the first houses to be lighted with Edison lamps. Francis Upton, a mathematician employed by Edison, also lived in this house. The Peins family occupied the house at the time of this April 13, 1933 photograph. Only the concrete retaining wall marks the former location of the home.

The Menlo Park post office also served as the railroad station for a time. The tiny building, photographed by J. Lloyd Grimstead on April 13, 1933, was located on the southeast side of the Lincoln Highway (Route 27), opposite Frederick Street and the Thornall house. The railroad tracks were located at the rear of the building.

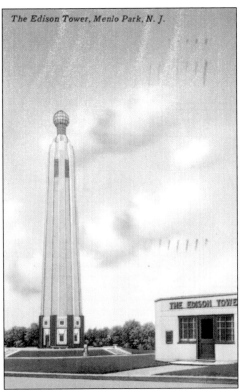

The Edison Tower, Menlo Park, N. J.

The Art Deco Edison Tower, located on Christie Street on the site of the Edison laboratory, was designed by the firm of Massena and DuPont and was dedicated on February 11, 1938. The 131-foot-high colored Portland cement structure contains at its peak a functional representation of Edison's first lightbulb. The bulb is 14 feet high and 9 feet in diameter. The Edison Tower and adjacent museum are depicted here in a 1955 postcard.

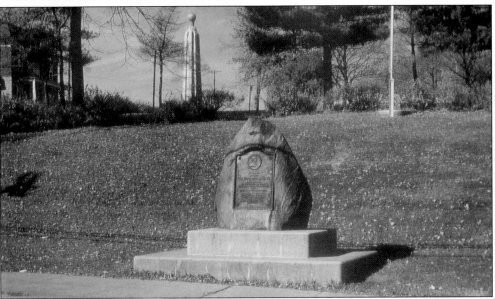

The Edison marker on Route 27 was dedicated on February 9, 1947, to celebrate the 100th anniversary of Thomas Edison's birth on February 11, 1847. Speakers at the dedication ceremony included Edison's son Charles Edison, who was a governor of New Jersey and a secretary of the U.S. Navy. Seen here in December 1958, the Edison Tower on Christie Street is in the background. The hillside has since become overgrown and the tower is no longer visible from this location. (Bill Ainsley.)

Two

PISCATAWAYTOWN AND NIXON

Seen here in 1932, the 18th-century Col. John Dunham House at 33 Park Way was the home of early settlers, the Dunham family. George Washington, Alexander Hamilton, and some of their troops ate breakfast prepared by the family on July 10, 1778, as evidenced by a receipt in the Library of Congress. The house has a stone foundation and has since been covered with aluminum siding.

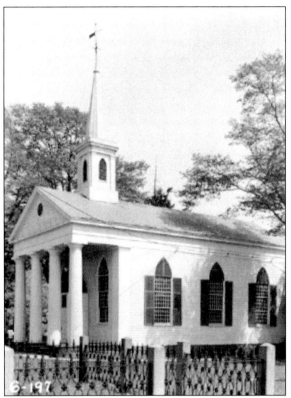

St. James Episcopal Church was reconstructed in 1836 after a tornado caused the collapse of the 1724 building. The original pulpit, floors, foundation, and bell from Leeds, England, were all reused. The building was extended in 1913 and the parish house was constructed in 1914. Documentation of the building by the Historic American Buildings Survey (HABS) in 1936 consisted of photographs (including this one), measured architectural drawings, and historical research.

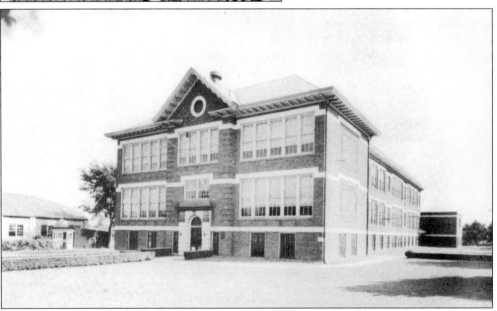

Piscatawaytown School No. 3, seen here in 1938, is located at 2060 Woodbridge Avenue. Constructed in 1913, the original eight-room building was designed by architect Lawson Merchant; later additions were attached to the south elevation. The school is remembered as the first township school to have a telephone. After it closed in 1984, the Rabbi Jacob Joseph School purchased the building.

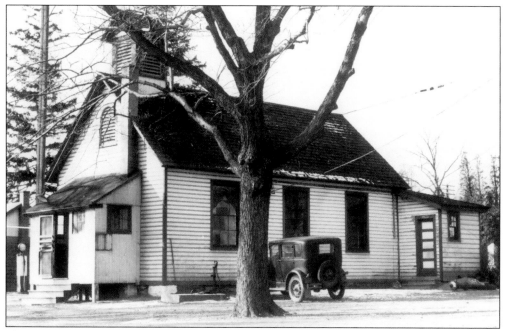

This one-room building stood behind St. James Episcopal Church on Woodbridge Avenue at Park Way. Constructed in the mid-19th century, it was used over the years as a meetinghouse, a school, township hall, police headquarters, and rescue squad headquarters. Plans were under way in the 1980s to use it as a township historical museum, but the building was badly damaged in a fire and was demolished in 1988. (Paul Stephens.)

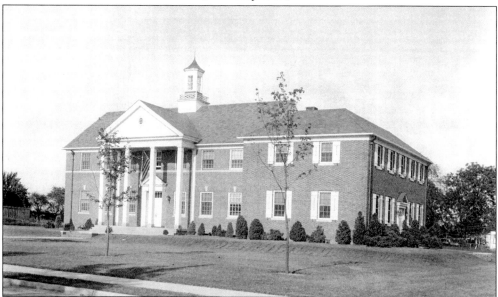

Raritan Township Town Hall was constructed in 1938 with assistance from Public Works Administration (PWA) funds. The building is located at the northeast corner of Plainfield and Woodbridge Avenues and faces Plainfield Avenue. The addition was constructed in the 1950s. After the Edison Municipal Complex was completed on Route 27 in 1980, the building was sold to the Rabbi Jacob Joseph School. (Remson Kentos.)

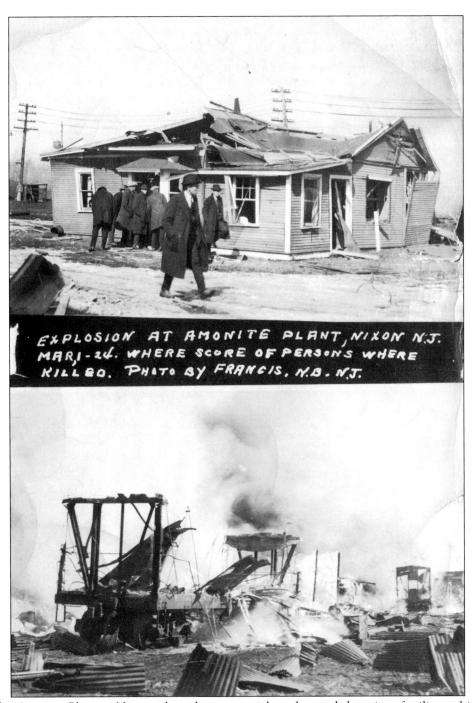

The Amonite Plant in Nixon salvaged war materials and turned them into fertilizer, which involved the handling of highly explosive materials. The plant exploded on March 1, 1924, leaving 18 dead and 100 injured. The blast was felt within a 20-mile radius. Accounts tell of the wounded being carried to the Woodbridge Avenue trolley to be taken to the hospital. Because of the disaster, residents became fearful of activities at Raritan Arsenal, although unrelated to the Amonite Plant, where surplus explosives from World War I were stockpiled.

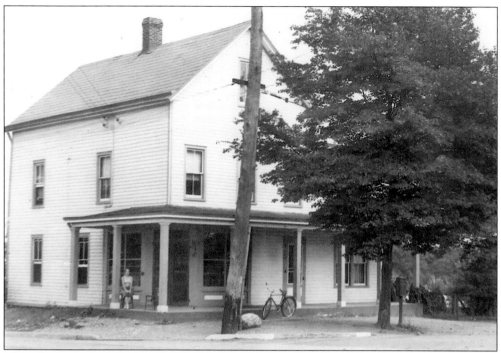

The John H. Hansmann grocery store and residence, seen here in 1938, was located at the corner of Woodbridge Avenue and Meadow Road. Notice the woman seated on the porch. This building may now be the Edison Millwork and Hardware store on Woodbridge Avenue, just east of the Old Post Road/Meadow Road intersection. (Remson Kentos.)

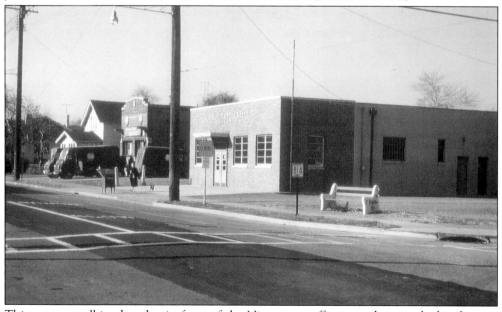

This woman walking her dog in front of the Nixon post office was photographed in January 1961. The former firehouse next to the post office was in use at that time by the Canteen Company, a vending machine service and supply company. Notice the delivery trucks parked outside. The Swales house is located to the left of the former firehouse. (Bill Ainsley.)

J. Leo Meyer and his wife, Elsie, pose in 1915. That year, at 271 Old Post Road, they built their house, which is still standing on the south side of Old Post Road, between Meyer and Melville Roads. Leo was the pitcher for the Raritan Township baseball team.

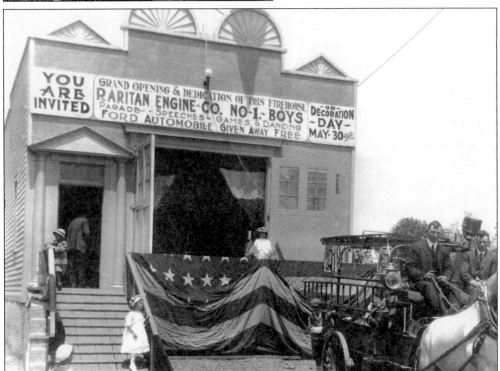

The grand opening of the Raritan Engine Company No. 1 was marked by festivities on May 30, 1917. The firehouse was located at 2161 Woodbridge Avenue on what is now a parking lot. Here, while three children look on, a small boy catches a ride on the running board of the wagon at right. (Ruth Swales Bernat.)

The iron gong used as an alarm to call the firemen was big enough for Cora Swales O'Connor to stand in. The firehouse did not have a telephone. The gong stood next to the firehouse until 1922, when an air horn was installed. Prior to 1922, when a report of a fire was telephoned into the candy store across the street, someone would run and tell Ruth Swales, who would then ring the gong. (Ruth Swales Bernat.)

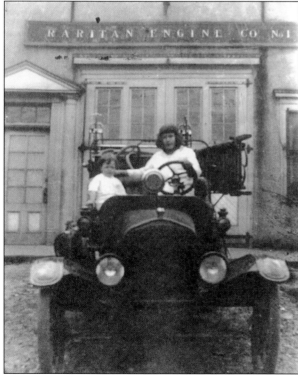

Ruth Swales Bernat, left, and her sister Cora Swales O'Connel try their hand at driving the fire truck. The girls' family lived next door to the Raritan Engine Company No. 1 firehouse on Woodbridge Avenue. Their small bungalow now contains Bob's Lock and Key. (Ruth Swales Bernat.)

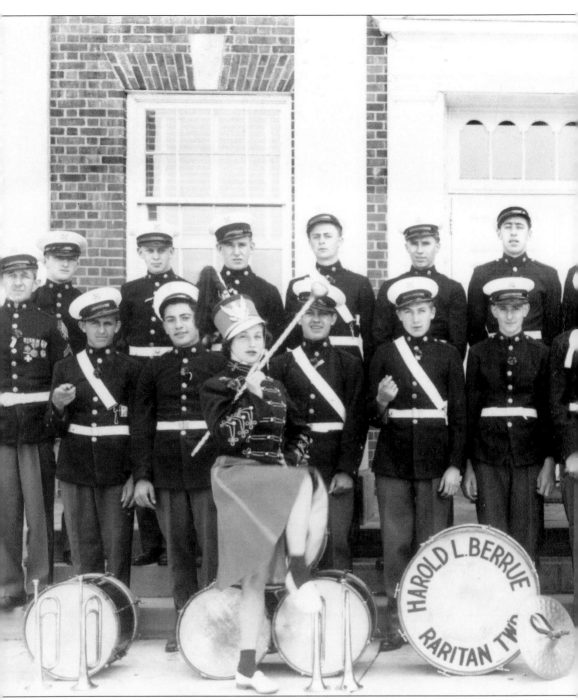

The Harold L. Berrue Drum and Bugle Corps poses in front of the town hall before the 1940 Memorial Day parade. Pictured, from left to right, are the following: (front row) Alice Coriell, Eileen McNulty, and unidentified; (middle row) Mr. McNulty, unidentified, A. Bekerian, Charles DeaKyne, Clarence Latham, George Ellmyer, Walter Keene, Theodore Gierlich, Frank Schuster, Calvin Latham, Edward Fiedler, and unidentified; (back row) Robert Voorhees, Harold McGovern, unidentified, Frank Betus, James Madarasz, Robert Davis, Roscoe Burton,

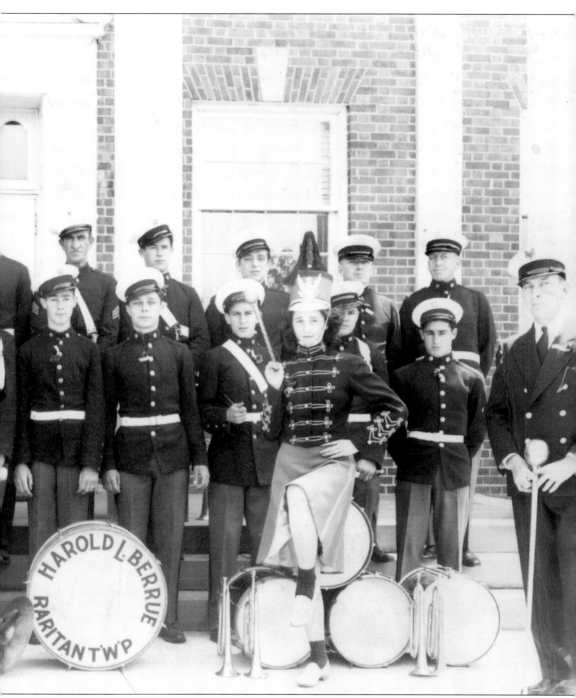

John Casleo, Richard Williams, ? Miller, Howard Furback Sr., and Leonard Wait Sr. The parade also included the Harold L. Berrue American Legion Post No. 246, the township school safety patrols, the police department, Engine Company No. 2, the Menlo Park Fire Company, the Raritan Township Exempt Firemen's Association, the Fire Commissioners of District No. 1, and the Piscatawaytown Safety Squad and ambulance. (Alice Coriell Calamoneri.)

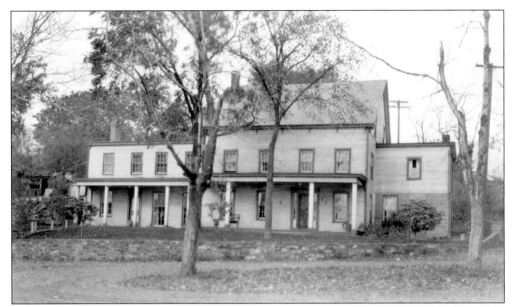

The 19th-century Lupardus house, visible on the 1876 township map, is located at the end of Silver Lake Avenue facing the river. The house was photographed on October 26, 1932. The Raritan River Boat Club was formed here in 1934 by a group of boaters who then moved the club to Player Avenue. Member Frank Langenohl lived in the house at that time.

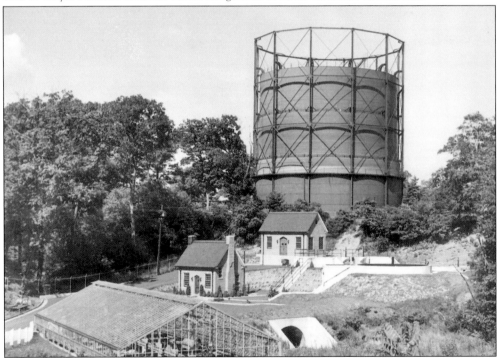

The Raritan Township Disposal Plant, seen here shortly after it opened, was constructed in 1938. Located at the end of Silver Lake Avenue in the PSE&G complex, these quaint buildings are still standing but have been abandoned and are barely visible amid the dense vegetation. The PSE&G gas tanks in the background have been demolished. (Remson Kentos.)

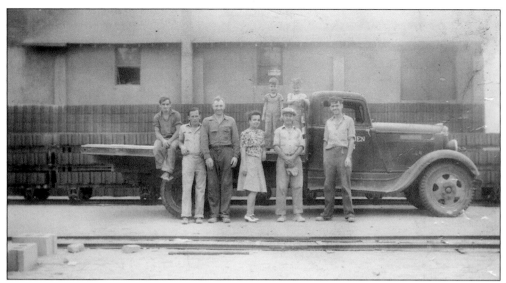

This smiling group poses in front of a flatbed truck at the R.C. Smalley Block Plant in July 1941. Located on Woodbridge Avenue at Dunham's Mill, the building, which was used in the construction of concrete block, was demolished in 1961 to make way for the Benjamin Franklin Elementary School. (Remson Kentos.)

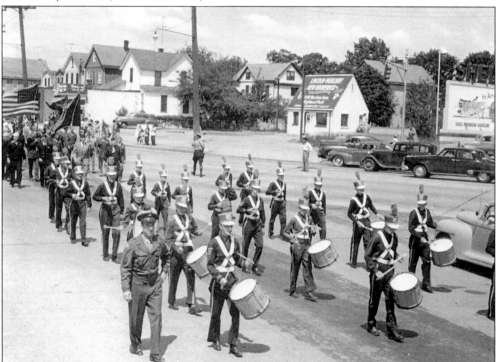

The c. 1950 Memorial Day parade along Woodbridge Avenue stopped traffic on U.S. Route 1. Marchers included the American Legion post, Raritan Engine Companies No. 1 and No. 2, the Edison Volunteer Fire Department of Menlo Park, the New Brunswick Fire Department, the Boy Scouts, the Girl Scouts, the Veterans of Foreign Wars Drum and Bugle Corps, the Panthers Athletic Association float, and the St. Mary's Band of New Brunswick, seen here.

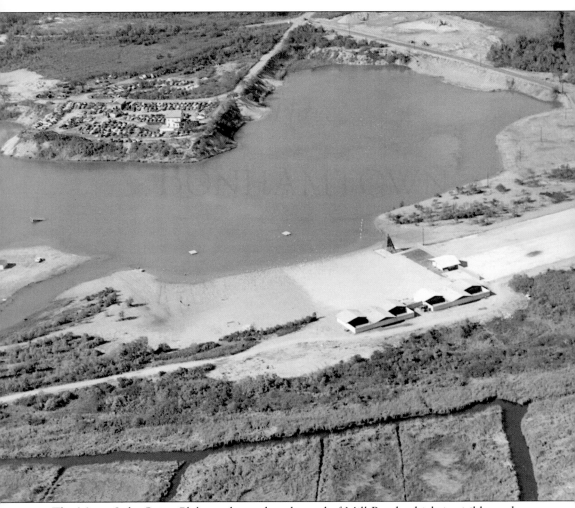

The Mirror Lake Swim Club was located at the end of Mill Road, which is visible at the top of the photograph. Families joined the club, the grounds of which are seen here looking north c. 1959, to provide a place to play and cool off on hot summer days. The township Democratic committee hosted picnics there for many summers. The lake was created out of an old sand or clay pit, perhaps one belonging to the New York Fire Proof Building Company, which operated clay pits at the end of Mill Road during the late 19th century. The property was filled in during the 1980s and warehouses were constructed on the site. This photograph was taken by Joseph Koye. (Rich Odato.)

Three

BONHAMTOWN

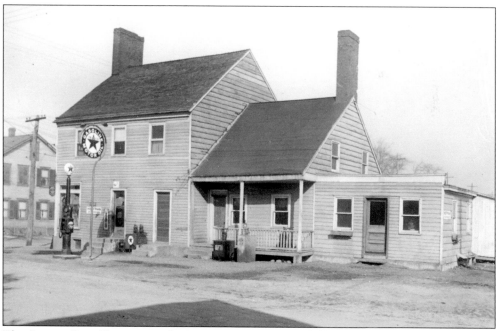

The Jerome Ross House, seen here in use as a store and filling station, was located at the northeast corner of Main Street and Woodbridge Avenue. It is said to have been occupied by British officers during the Revolutionary War. The village of Bonhamtown was centered on the intersection of Main Street, Woodbridge Avenue, and Old Post Road. At the time of this 1930 photograph, Bonhamtown residents numbered just 800, with two small churches, a school, and a general store.

The Bonham House, also known as the Carpenter House, was constructed before 1776 on Old Post Road. It is said that a British spy was shot in this house during the Revolutionary War. The center bay window is a modest Victorian addition to a much older house. Early settler Nicholas Bonham provided the village its name. Bonham was a freeholder in 1682 and 1683.

The c. 1770 Charles Ford House, seen here in a 1937 Historic American Buildings Survey photograph, was located on the north side of Old Post Road, a half mile south of U.S. Route 1. The New Jersey Turnpike now goes through the site. At the time of the photograph, the clapboard house was covered with asphalt shingles, an economical choice during the Great Depression.

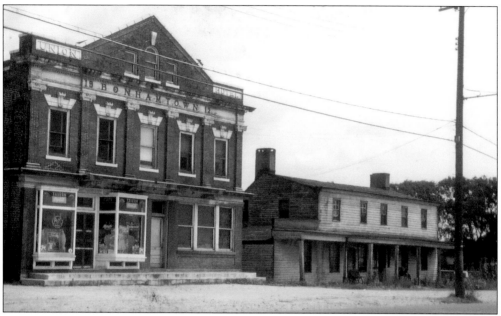

The site of the 1912 Union Hotel (left) and Joseph Tappen's c. 1740 tavern is now the location of Victorian Manor catering hall and shopping center. Bonhamtown was witness to the Revolutionary War as the site of several skirmishes and encampments of several regiments of British soldiers. In 1834, the small village featured just a dozen dwellings, two taverns, a store, and a schoolhouse. (Bill Ainsley.)

The Grimstead brothers, uncles of photographer J. Lloyd Grimstead, operated an ice business near their home on Old Post Road. The ice was cut from the millpond on the north side of Old Post Road, seen here in an undated photograph, and was stored in the icehouse on the right. In the summers before refrigeration, the brothers would haul the ice and sell it to Metuchen households.

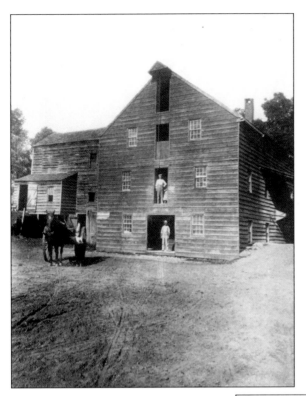

John Eggert (on second floor), his son Robert (on first floor), and an associate pose in front of Eggert's Mill. Seen here c. 1890, the mill was located on the south side of Old Post Road on the east side of Mill Road. The business was known during the 1870s as the Mundy & Eggert gristmill. Originally, water powered the mill wheels. A steam engine was later added to turn the turbine waterwheel.

Sine and Rasmus Clausen pose in their garden in this undated photograph. They owned a large farmhouse on the corner of Clausen Road and Woodbridge Avenue. They were also responsible for building houses for their children on Sine Road and on other nearby streets. The neighborhood is now filled with single-family homes dating from the 1950s through the 1970s. (Nancy Dudling.)

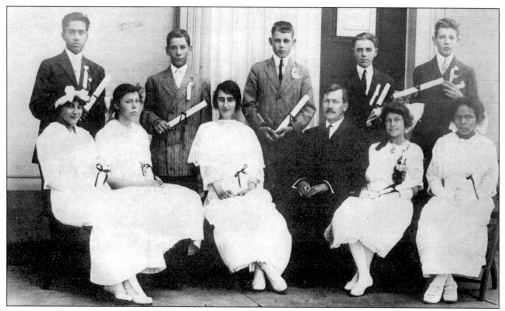

Diplomas in hand, the c. 1917 graduating seventh-grade class of the Bonhamtown School poses with teacher Wilfred R. Woodward, seated fourth from left. At that time, Bonhamtown was still a country village with two churches and a general store along a winding road. Located at 2825 Woodbridge Avenue, the school was constructed of local brick. The graceful building features corner quoins and Ionic columns that support an elliptical pediment.

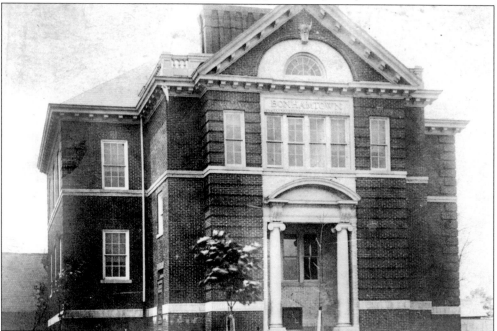

The Bonhamtown School—located at the intersection of Woodbridge Avenue, Old Post Road, and Grace Street—was constructed in 1908. One of the school's teachers, D.F. Thornall, sent this card to a friend in 1913 with the message "This is where I teach—upstairs on the left. I have 48 [students]. There are 180 in the school."

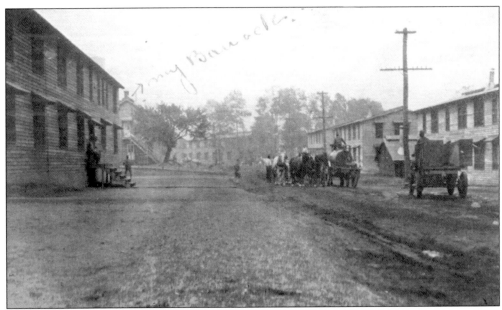

Raritan Arsenal, originally known as Camp Raritan and also as Raritan River Ordnance Base, was established in 1917 in preparation for the entry of the United States into World War I. The arsenal—initially a 2,150-acre complex with 275 buildings, 52 miles of railroad, and 6 miles of concrete roads—played a key role in the transport of war materials to both Allied and American armed forces in Europe during World War I.

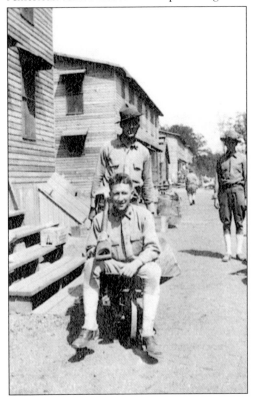

Raritan Arsenal was situated on approximately five square miles of land with miles of gravel road and docks along the Raritan River. The complex included 13 large manufacturing buildings, a hospital group of 13 buildings, 170 barracks buildings (seen here in the background), 29 mess halls, 29 latrines, 2 administration buildings, a post exchange, garages, stables, offices, and 192 magazines. (Courtesy of Jeanne Kolva.)

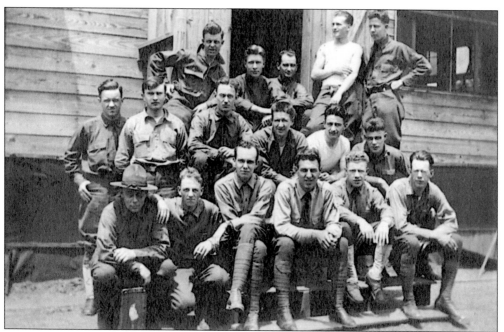

During breaks, World War I soldiers at Raritan Arsenal could relax by the barracks, visit the YWCA Hostess House, or visit the YMCA, Knights of Columbus, Red Cross, and Jewish Welfare League buildings that had been constructed at the camp. After the war, a library, a swimming pool, and a golf course (now the site of Middlesex County College) were added. (Courtesy of Jeanne Kolva.)

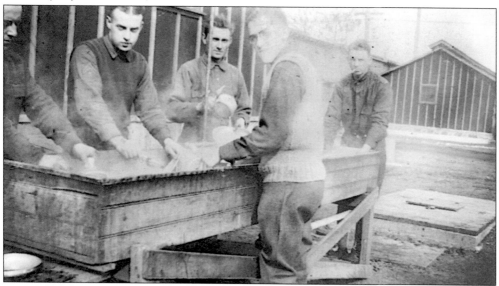

Washing dishes was a small part of the bigger operations that took place at Raritan Arsenal. Many of the arsenal buildings, such as the tarpaper-covered ones in the background, were originally intended to be temporary. The hastily constructed buildings included enlisted men's barracks and the hospital. Plans were under way by 1922 to replace these temporary buildings with permanent construction; however, many of them remained until 1939. (Courtesy of Jeanne Kolva.)

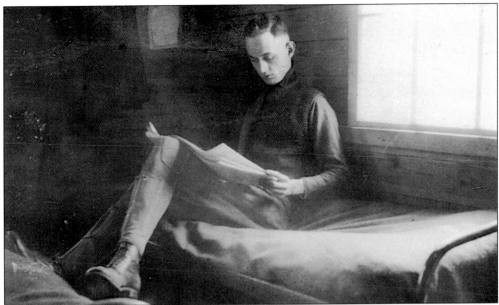

Raritan Arsenal served as a major East Coast storage and transshipment center for munitions and as an ordnance training camp for 20,000 American soldiers. Recreational facilities were provided for the soldiers, but this unidentified soldier preferred to read quietly on his bunk. Much of the arsenal is now part of Raritan Center Corporate Park, Middlesex County College, or county park property. (Courtesy of Jeanne Kolva.)

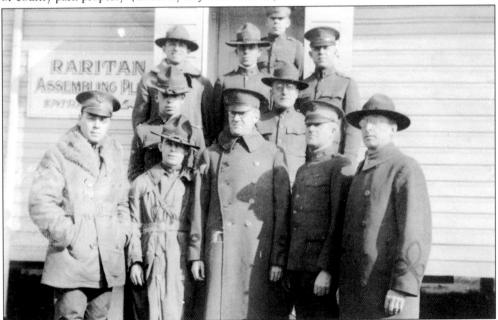

During the 1920s and 1930s, the primary purpose of Raritan Arsenal was the storage, salvage, and renovation of munitions. The facility also supplied assembly and repair services for the more advanced military technology that was developed during these decades. Many of the frame buildings were removed between the world wars. Several of the large brick buildings along Woodbridge Avenue were demolished in the 1990s. (Courtesy of Jeanne Kolva.)

The Bloomfield family, seen here in an undated photograph, relaxes on the steps of their home. Charles A. Bloomfield and his wife, Mary, are seated at center and left. Their daughter-in-law Anita, who was married to their son Howard, is seated at top. Their two grandsons, Howard (Lundy) and Harold, are seated at right. The boys would later have a sister, Eleanor.

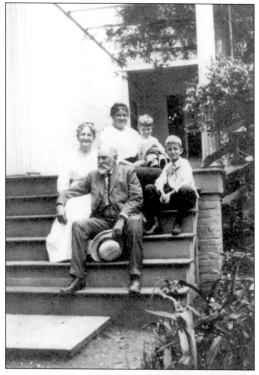

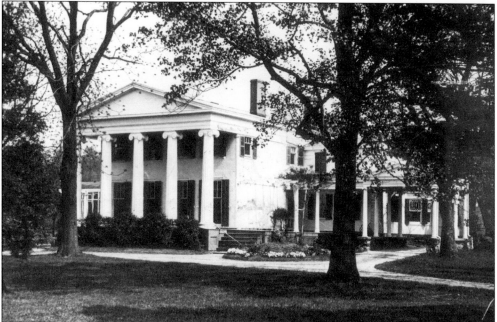

The central portion of Bloomfield Manor was constructed c. 1810 under the direction of Smith Bloomfield, grandfather of Charles Bloomfield. In 1921, the mansion was described as a rare old building, with a library trimmed in black walnut hewn from a tree on the property. The house was enlarged over time by family members, including Charles, who added the east wing, seen here at right.

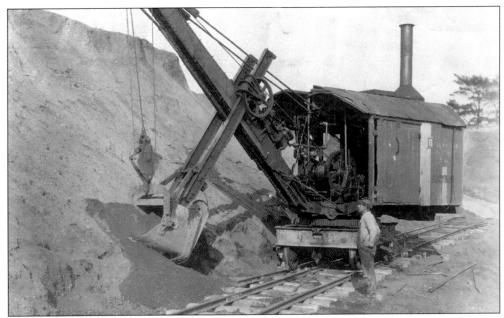

The Bloomfield Clay Company steamshovel removes the top layer of gravel and sandy soil in order to access the clay deposits underneath. Charles Bloomfield was a leader in the clay industry and served as president of the New Jersey Brick Manufacturer's Association, as well as president of the New Jersey Clay Workers' Association. He also founded the Department of Ceramics at the State Agricultural College (now Cook College) at Rutgers University.

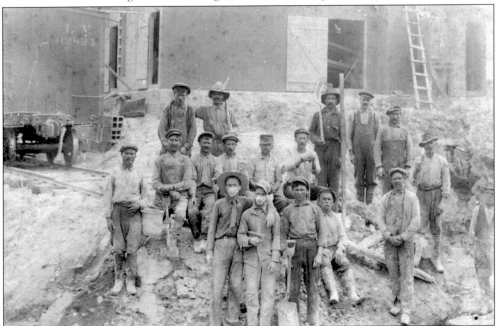

Work in the clay pits was a dusty affair. During the late 19th century, the men who worked here in the clay banks labored 10 hours a day and earned 10¢ or 11¢ an hour. The clay pits were located on the bluff along Woodbridge Avenue, two miles from the river. This area is now part of Raritan Arsenal.

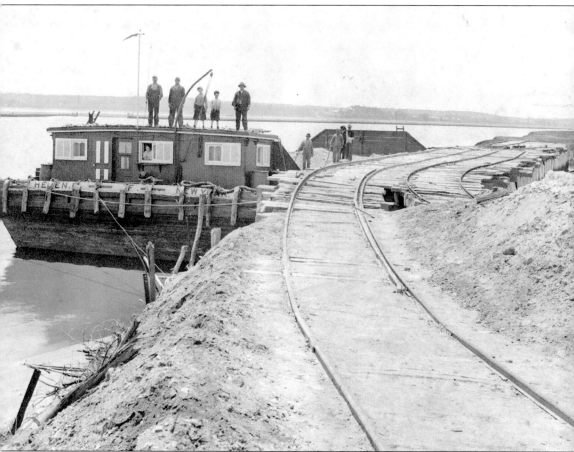

The proximity of the Raritan River to the clay pits facilitated transport to market. The men and two boys on this boat, perhaps docked at the Bloomfield Clay Company, awaited materials to be brought from the gravel, sand, or clay pits. Notice the man looking out of the window to the right of the door. The railroad siding, center, brought cars of materials from the pits to the dock for shipment. The area between the Raritan River and Woodbridge and Amboy Avenues was largely salt marsh that was just a few feet thick. Beneath the marsh turf was 10 to 60 feet of clay that would swallow you up if you fell into it, according to David Marshall. The turf was not suited to farming. Area farmers would cut the marsh grass and wait until winter, when the turf would freeze solid. They could then lead a wagon team across the marsh to load the hay, which they would feed to their cattle.

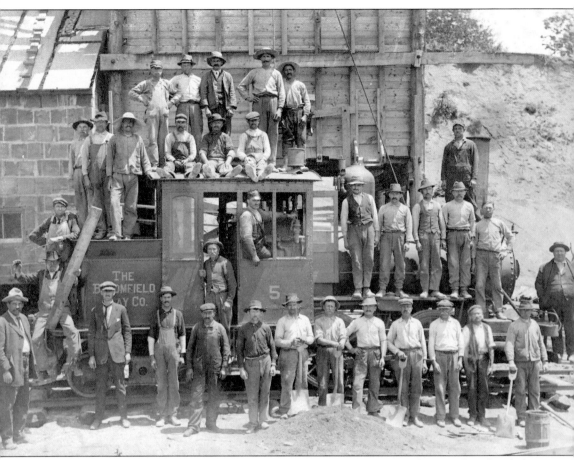

Seen here in an undated photograph, Bloomfield Clay Company employees take a break from work for the photographer. By 1875, clay and sand pits were being excavated both north and south of the Raritan River. Railroad lines were built to service these industries, and an 1876 map shows a railroad labeled "Clay Cos R.R."

In addition to Bloomfield, at least five other area firms mined, shipped, and manufactured fire clay and sand during the late 19th and early 20th centuries. They included A.M. Mervin (near Fords), the M.D. Valentine & Brother Company (located between Metuchen and Fords on the Lehigh Valley Railroad), Raritan Ridge Clay Company (which mined clay, sand, and kaolin and shipped the materials via docks on the north shore of the river), Robert N. and Howard Valentine, and Henry Maurer & Sons. The thriving Bloomfield concern went out of business in 1930 after more than 50 years of operation.

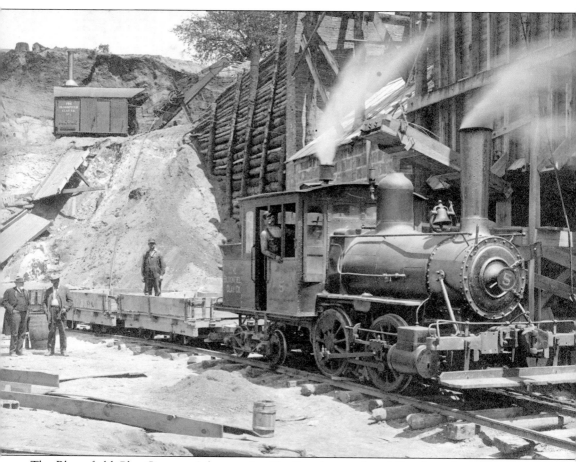

The Bloomfield Clay Company's locomotive No. 5 and steamshovel No. 1 are shown here in the company's open-pit clay mine. The timber cribbing, right, supports a trestle on which rail cars were pulled over the pit. The man on the left with the white beard is believed to be Mr. Bloomfield. The father of David Marshall, author of *Boyhood Days in Old Metuchen*, surveyed a railroad for Mr. Bloomfield in 1880. The railroad ran from the clay banks on Amboy Avenue to the Raritan River. Horses or a lightweight locomotive pulled railroad cars, as a heavyweight locomotive would fall right through the shallow turf. It was difficult to lay out railroads in the area because the turf on top of the clay was very shallow, causing the road to buckle and sag with the annual freeze-and-thaw pattern. Fill was added in the gaps, and the road would frequently need to be re-laid.

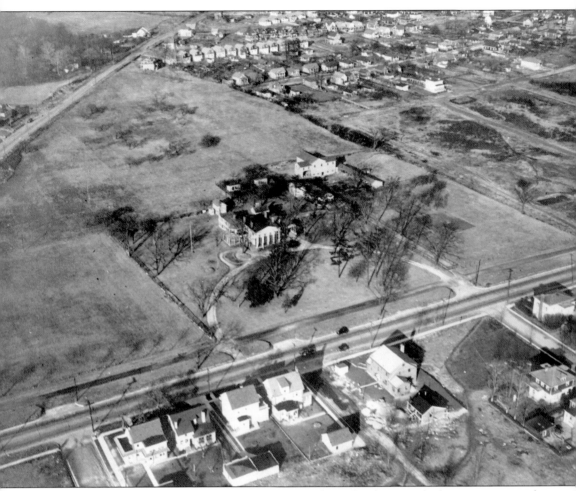

Looking northeast, this 1950s photograph shows how development had come to meet the Bloomfield property, which had been in the Bloomfield family since 1639. Notice the curb cuts leading from Amboy Avenue in the foreground. The dirt road in the background is Woodbridge Avenue. The property was subdivided and new roads were constructed between 1952 and 1956. A professional office, an apartment complex, and many single-family homes are now located on this site. The neighborhood, once known as Ford's Corners, has changed dramatically in the last 50 years with the nearby construction of the New Jersey Turnpike, Interstate 287, and the large interchanges that connect both to Woodbridge Avenue. These routes travel through what were the 19th-century communities of Sand Hills and Ford's Corners.

Four

STELTON

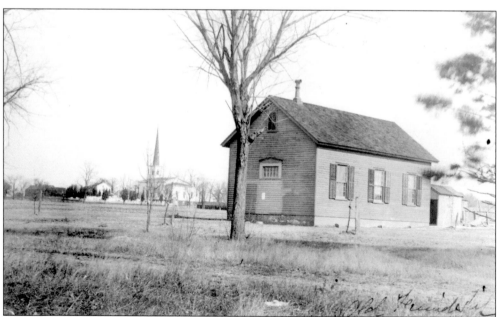

The one-room Stelton schoolhouse, seen here *c.* 1882, was located on Division Street behind the Baptist church, visible in the background. Prior to 1904, the township contained 10 school districts, nearly all of which consisted of a one-room school. After Metuchen and Highland Park left the township, a movement for larger schools began and two four-room schools—Bonhamtown and Oak Tree—were built. (Ruth Smith.)

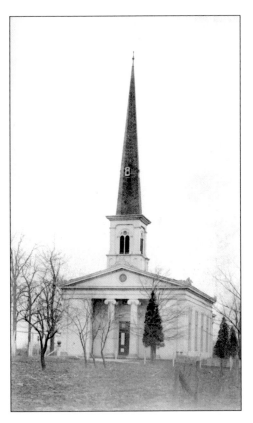

The second Baptist congregation in New Jersey was organized in Piscatawaytown in 1689 by European settlers. The church was known as the First Baptist Church of Piscataway (of which Stelton was considered a part) until 1875, when it was renamed the Stelton Baptist Church. The third Stelton church building, constructed in 1851, is seen here before winds toppled the steeple in 1912. This building was destroyed by fire in 1924.

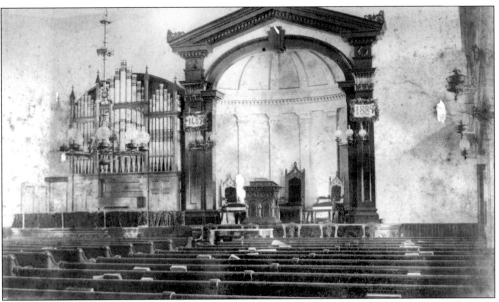

Shown in 1889, the interior of the third Stelton Baptist Church is decorated for the celebration of the congregation's 200th anniversary. Early settlers Hugh Dunn, John Smalley, Nicholas Bonham, Edmund Dunham, John Drake, and John Randolph formed the congregation in 1689. Dunham was the first child of the earliest settlers to be born in Piscatawaytown. (Ruth Smith.)

This undated photograph, taken from Runyon Avenue, shows the Stelton Baptist Church, which was built in 1925–1926 at 324 Plainfield Avenue. The Runyon House is on the right. The Stelton School is partially visible at left. (Ruth Smith.)

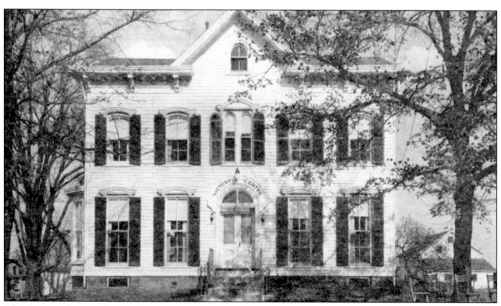

The Letson house, located at 349 Plainfield Avenue near the train station, became the Victory Center for servicemen while nearby Camp Kilmer was in operation. The building has been divided into apartments, and much of its architectural detailing has been removed.

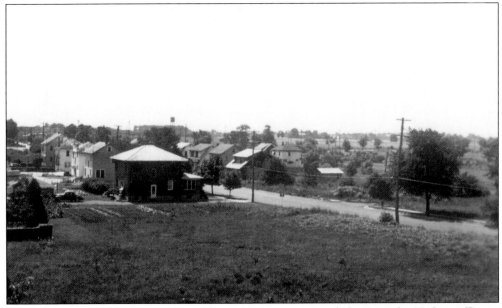

This view, looking southwest along Plainfield Avenue toward the Lincoln Highway (Route 27), was taken from across the street from the Baptist church. The view is continued in the photograph on the opposite page. In early years, the avenue was called Mountain Road because it led north to Plainfield and the Watchung Mountains. (Ruth Smith.)

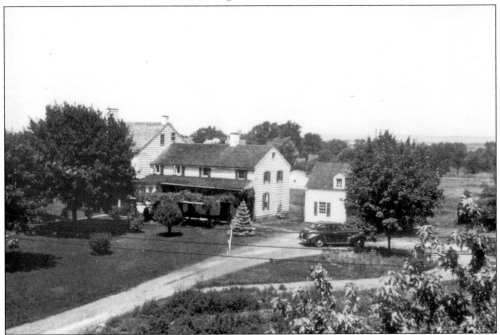

The Runyon homestead was located at the northeast corner of Runyon and Plainfield Avenues. Looking northwest, this view shows the oldest part of the house, reported to have been constructed in 1698. The Runyon and Sims families farmed the area between Route 27 and the Baptist church until World War I. The house was demolished c. 1970 and replaced by apartments. (Ruth Smith.)

54

The Dunellen bus traverses Plainfield Avenue in this undated photograph. The route, operated by Suburban Transit Corporation, connected New Brunswick and Dunellen via the Lincoln Highway (Route 27) and Plainfield Avenue. At one time, bus fare from Stelton to New Brunswick cost 17¢. Public Service Co-ordinated Transport Company also operated routes throughout the township. The Stelton School is partially visible at right. (Ruth Smith.)

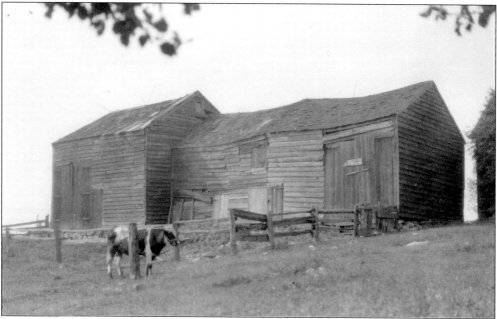

It seems almost impossible to believe that this 1933 country scene was on the south side of the Lincoln Highway, just west of Plainfield Avenue at what is now Division Street. The farm was known as the Tonilee farm or the Runyon farm. During the 1930s, the road still retained some of its farms amid the increasingly cluttered roadside services that later came to dominate the route in Edison.

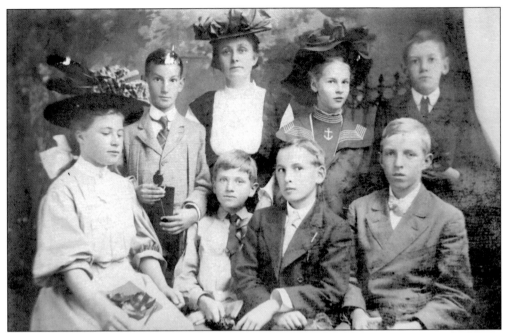

Teacher Susan Fillips, back row center, and pupils of the one-room Stelton School pose for a class picture during Fillips's teaching tenure at the school, 1907–1912. William Runyon is identified at the far right in the front row. Fillips began teaching in Raritan Township in 1892 and was principal of the Stelton School from 1924 to 1935. She retired in 1935 after 43 years of service.

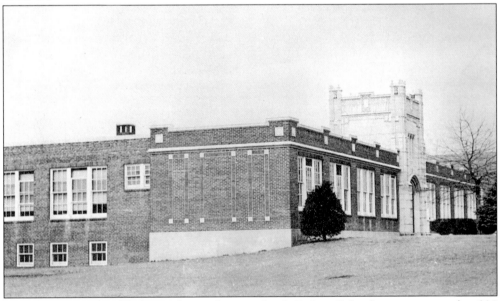

Between 1923 and 1925, the modern eight-room brick Stelton School was constructed at 328 Plainfield Avenue. The elementary school originally had four teachers, one of whom was a teaching principal. The auditorium addition was constructed in 1950. The school closed in 1982 due to declining enrollment. The building is now used as a community center, named for lifelong resident, township teacher, and township council member Dorothy Drwal.

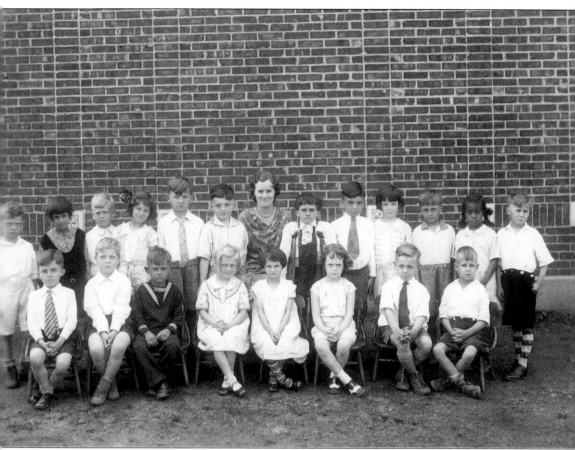

Florence Weber's first-grade class poses in front of the Stelton School c. 1929. Pictured, from left to right, are the following: (front row) James Wildman, David or Jack Porter, unidentified, Kirsten Hinricksen, Blanch Prime, unidentified, Ralph Reinhart, and unidentified; (back row) John Clyde, four unidentified students, Gilbert Tilbor, Florence Weber, John Contamessa, two unidentified students, John Homan, Lois Ellis?, and unidentified. It has been reported that the school was the first in the nation to offer a hot lunch program and the first in the state to immunize students. During the 1930s, the community of Stelton contained just 700 people. The population of the entire township in 1930 was 10,025 people, nearly double the 1920 count of 5,419, but still far removed from the huge population boom that came in the 1950s.

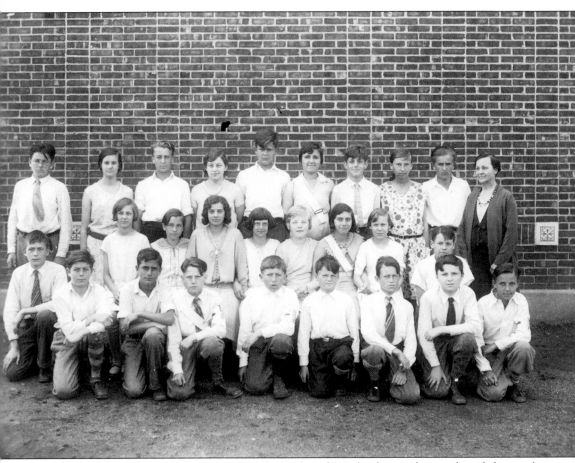

Elizabeth Swackhammer's 1929 Stelton School sixth-grade class is shown, from left to right, as follows: (front row) unidentified, ? Zafareno, John Gray, Albert Zdunek, Joe Changery, Michael Changery, Blake Clickner, and Eugene Horvath; (middle row) Ferdinand Breitenback, Isabelle Thompson, Evelyn Abbot, unidentified, Margaret Hubert or Horvath, Karen Hansen, unidentified, Doris Millemann, and William Kiefer; (back row) Harry Rosenhouse, unidentified, Paul Bruder or ? Kroon, ? Shebel, John Reider, Anna Nagy, Edward Ackert, Mary Pocsik, and unidentified. Swackhammer is at the far right in the back row.

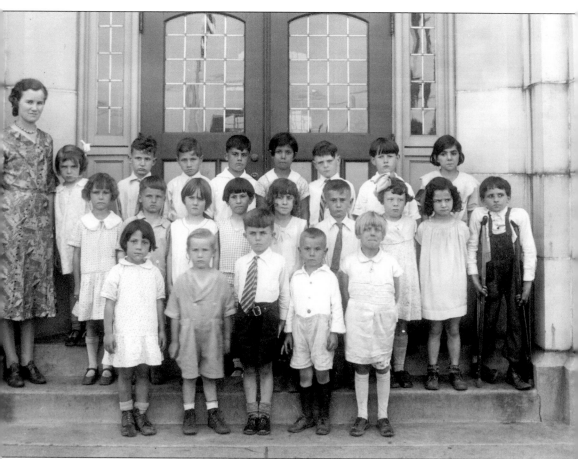

Judging from the unhappy faces in Florence Weber's c. 1931 Stelton School first-grade class, perhaps someone has just told them that recess is cancelled. Shown, from left to right, are the following: (front row) Francis Rogolino, George Auerbach, James Wildman, James Galayda, and Thelma Clyde; (middle row) Rose Waltz, John Homan, unidentified, Mary Kovacs, Mary Sgro, ? Reeder, Ruth Lowe, Florence Viel, and John Contamessa; (back row) all unidentified. The class is posed at the entrance to the school, which features limestone trim and arched openings. These are characteristics typical of what is often called the Collegiate Gothic style of architecture, because it was frequently used for 20th-century college campus buildings. The Stelton School has a two-story limestone center tower that is capped with four spires, giving it the appearance of a small castle.

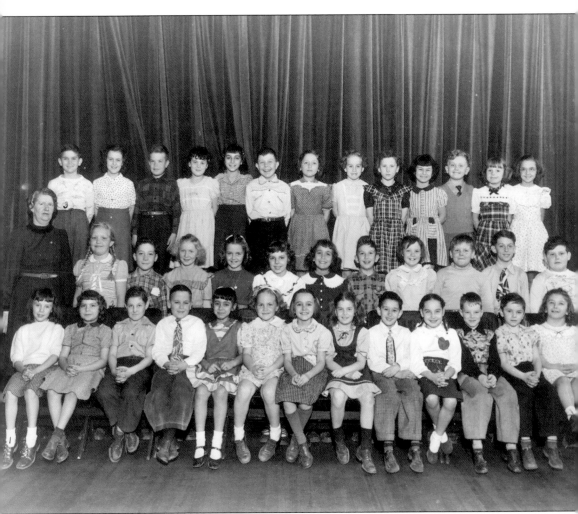

Teacher Sara Fillips and her third-grade class pose for their 1949–1950 Stelton School class photograph. Pictured, from left to right, are the following: (front row) Nancy Horst, Valdie Rizzo, John VanDerveer, Roger Bush, Jennie Rizzo, Judy Quigley, Stephanie Kardtz, Sandra Benton, George Lagdkos, Fay Mikalowsky, Byran Williams, James Moran, and Jo Deshety; (middle row) Kathleen Williamson, Patsy Rogolino, Rita Cree, Lois McKinley, Ellen Holus, Shirley Blum, Jack Marsh, Kathy Hofland, Rudolph Zeller, Harry Keyes, and Gary Summers; (back row) Charles Gombasi, Judith Keyes, Teddy Manhire, Rosemary Farlee, Eleanor Damoci, Richard Kozma, Patty Jean Muth, Kathryn White, Agnes Ellis, Loretta Holmes, Michael Rossani, Joanne Best, and Elinor Peckham. Sara Fillips taught in the school system for more than 37 years. She is the niece of Susan M. Fillips, who was a teacher and principal in the township school system for 43 years.

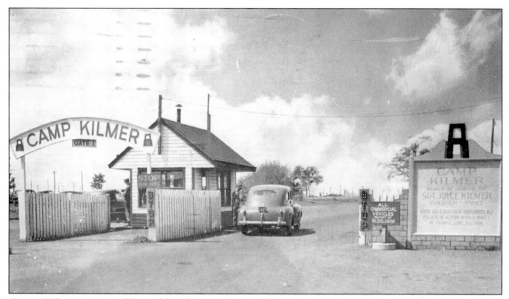

Camp Kilmer was established by the U.S. Army for troop processing and deployment. Ground was broken in January 1942 and in just four months 11,400 civilians constructed the camp on 1,573 acres of farmland in Edison and Piscataway Township. The camp was named for New Brunswick poet and writer Joyce Kilmer. Kilmer died in World War I at age 32 and is best remembered for his poem "Trees."

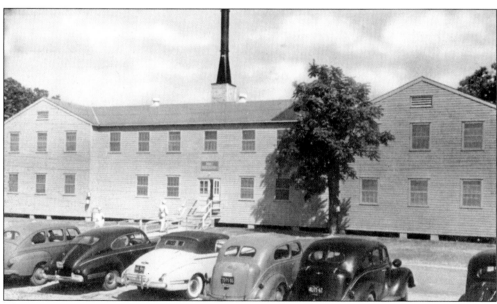

The camp's operations ran smoothly from the headquarters building, seen here. As many as 400 Pullman railroad cars could be filled with 58,000 soldiers in a 24-hour period, and the quartermaster corps was capable of outfitting 3,000 soldiers with uniforms and gear in an eight-hour day. Armed with eight-hour passes, 10,000 to 20,000 soldiers per week, once described as "a human tide of khaki," streamed into New Brunswick in search of entertainment.

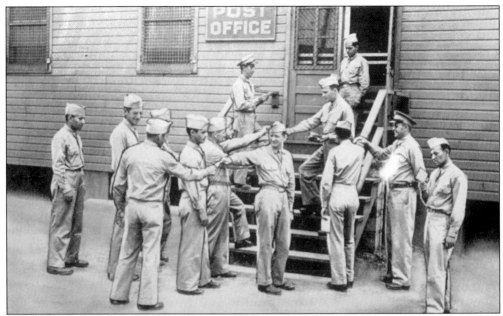

Camp Kilmer was unusual in that no training took place there; its role was to transport soldiers to and from the war zones. More than a third of all troops sent overseas during World War II (nearly 5 million soldiers) passed through Camp Kilmer. The uncertainty of the times contributed to the approximately 2,000 weddings that took place on post each year during the war.

Camp Kilmer, seen in this view looking east toward Plainfield Avenue, contained as many as 1,100 buildings, including dozens of barracks, a hospital, chapels, and the PX. The camp was deactivated in 1949. In 1956, some 40,000 Hungarian refugees were received here, with many eventually settling in Edison. The property has been divided to form Rutgers University Livingston College (549 acres), an industrial park, the Edison Job Corps, and a township park.

FIVE

NEW DURHAM AND VINEYARD VILLAGE

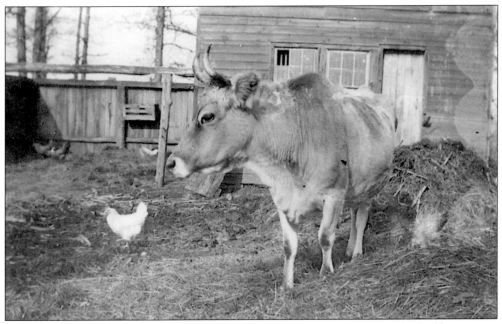

Kit, the End family's Jersey cow, shared the barnyard with the chickens. The building at rear was part of the original farmhouse and was replaced by a new section in 1881. This old section was moved northwest of the barn and was used as a henhouse. It burned *c.* 1932. The fire began at the Pennsylvania Railroad crossing on Talmadge Road and reached halfway to Stelton before it was extinguished.

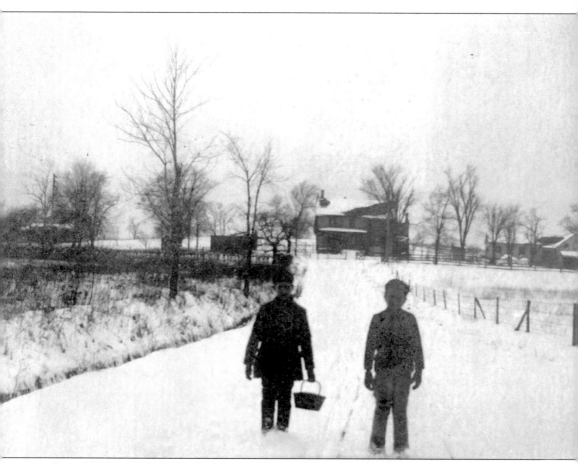

From 1897 to 1904, the End family rented a small house on the William Mundy farm, seen here in the background, which was located on the north side of Ethel Road where Talmadge Road used to terminate in a T intersection. Looking north, this *c.* 1904 view shows Norman Mundy (left) and Charles End (in silhouette) standing in the middle of Talmadge Road in front of the farm. The photograph was taken by Lell (Leopold) Litterst. At this time, Talmadge Road made a sharp turn east around the farm and turned immediately north to continue into the Dismal Swamp. The northerly bend in the road is just visible at the right edge of the photograph along the fence line. The Mundy house is at center and Will Mundy's workshop is at right. A later owner, Borgfeldt, used the workshop for the manufacture of cigar-bunching machinery. Beyond the second clump of trees at left was the house rented by the End family.

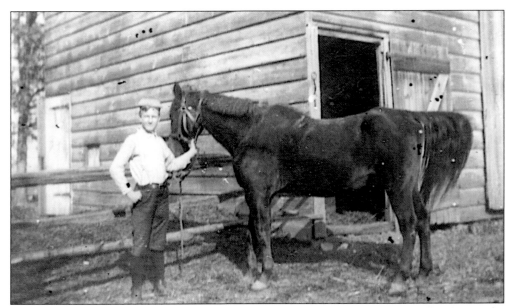

Teenager Charles End poses with his horse Jim—the "plodder," as End called him—beside the barn c. 1908–1910. Charles F. End (1893–1985) went on to serve as a township committeeman and water commissioner. In addition to his extensive civic contributions, End contributed greatly to the history of the township through the detailed accounts of township life that he donated to the historical society.

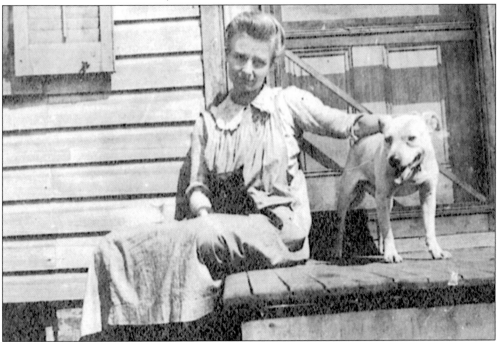

Charles End photographed his sister Anna Adele End (later Goodwin) c. 1904 as she relaxed on the kitchen steps of the family home with the family cat and bull terrier, Sport. The End house was located about 1,000 feet north of the railroad on the west side of Talmadge Road. After Uncle Will End died in 1904, the family returned to the farm and stayed there until 1928.

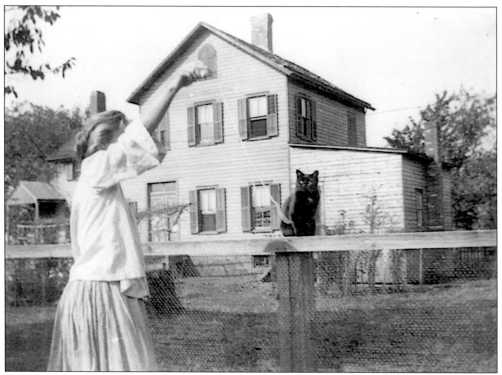

Anna End plays with the family cat in front of the house *c.* 1908–1910. The kitchen wing at right was added in 1904, the same year the family moved back to the farm from their rental house at the Mundy farm. Francis B. End purchased the property in 1856.

All was quiet after harvest time in the cornfield northwest of the End house *c.* 1908–1910. Talmadge Road has changed dramatically over the last few decades, most dramatically with the realignment to allow through traffic past New Durham Road and into Dismal Swamp.

Theodore N. End, father of Charles and Anna, is shown riding Jim *c.* 1908–1910. In 1932, with the economies forced by the Great Depression upon them, Charles End and his wife left their rental house and moved back to the family farm, which was then updated with electricity, telephone service, and running water. The End family sold the farm to the American Cholesterol Company (Amerchol) in 1964, and a factory (existing) was constructed on the site.

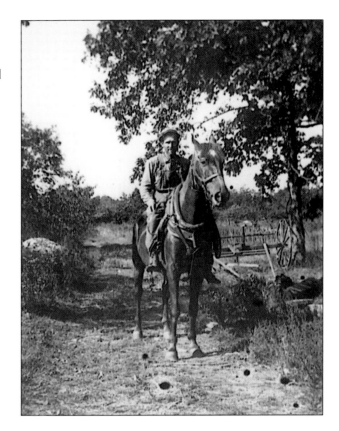

The D. Vail house, also known as the Christensen house, was located on New Brooklyn Road. It is shown here on November 21, 1932. The weather must have just turned chilly, as the storm windows are stacked at the right side of the house waiting to be hung. The Martin family burying ground is west of the house. The house is no longer standing.

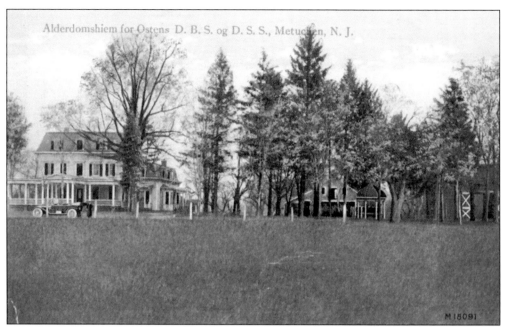

The Danish Home for the Aged, shown in this c. 1918 postcard, was established in 1914 by the Danish Brotherhood of America to house aged members and their wives and widows. Toward this purpose, the home purchased the 72-acre Tonnele farm on New Durham Road where Interstate 287 is now located. Eighteen residents moved into the existing home at 855 New Durham Road in 1951. The old home burned in 1953.

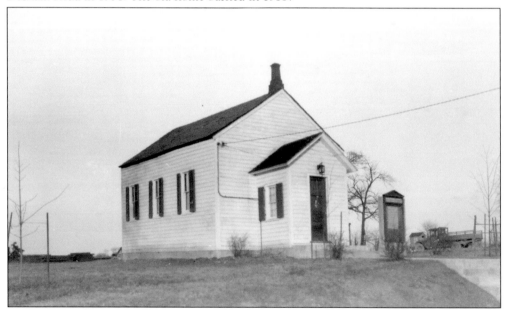

Seen here in 1933, the New Durham Chapel, also known as the Union Chapel, was located on New Durham Road. The congregation later moved to larger quarters and this building was demolished. New Durham was a crossroads community at the intersection of New Durham Road and New Brooklyn Road, composed of only a few families and a schoolhouse until the 1940s. This intersection now shows no signs of its earlier incarnation.

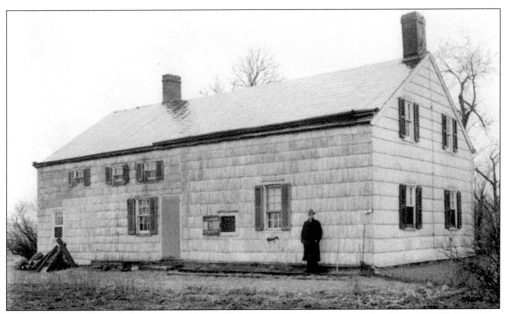

The nearly unaltered Benjamin Shotwell House, also known as the Runyon House, was constructed on Runyon's Lane sometime between 1750 and 1775 and is listed on the National Register of Historic Places. This photograph of the north (rear) elevation was taken for the Historic American Buildings Survey in 1939. The remainder of the small farm was demolished with the construction of Interstate 287, which is located behind the house.

The Boyd family poses in front of their house on Vineyard Road in 1907. Fred and Gertrude Boyd moved to this house in 1895 and farmed the land. Vineyard Road was an early route through the area connecting Metuchen to Old Post Road midway between Piscatawaytown and Bonhamtown. It appears in an 1804 series of engraved maps of the main road between New York and Philadelphia. (Jane Fort.)

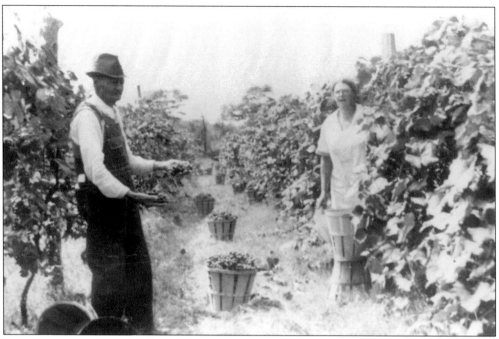

Fred and Gertrude Boyd pick grapes for market on Vineyard Road in 1939 or 1940. Although vineyards are not common in New Jersey, there are references to Edward Antill's vineyard in Piscataway Township as early as 1765. Based on its description, Antill's 800-vine vineyard was closer to New Brunswick than to Vineyard Road; however, its presence is notable for its early date. (Jane Fort.)

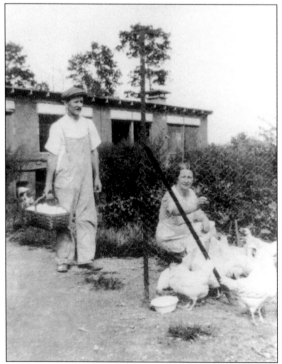

Harry Turschmann's parents, Albin and Martha, are hard at work feeding the chickens and gathering eggs in 1945. Harry and Walter Turschmann's uncle Bruno Eberborcht also had a chicken farm on Vineyard Road. (Dorothy Turschmann.)

Still just a dirt road in March 1930, Vineyard Road appropriately got its name from the vineyards that were located along its route. The road has long since been paved, due in large part to the heavy traffic that travels it between Route 27 and U.S. Route 1. (Dorothy Turschmann.)

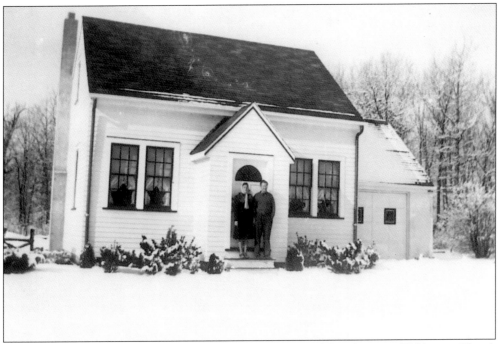

Harry and Dotty (Dorothy) Turschmann pose on the steps of their house at 78 Vineyard Road. Harry's brother Walter, a carpenter, built the house in 1945 immediately across the street from their parents' house. Mail was not delivered to Vineyard Village, as this rural area was called. As late at the 1950s, residents' mail was sent general delivery to the Metuchen post office. (Dorothy Turschmann.)

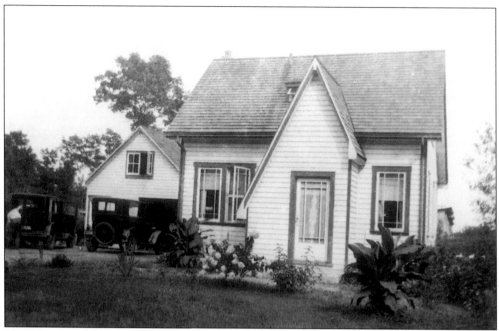

The Turschmann home, constructed in 1929, was located at the southern end of Vineyard Road near the present-day entrance to the Ford Motors truck assembly plant. The house and the chicken coops out back were demolished in 1972. (Dorothy Turschmann.)

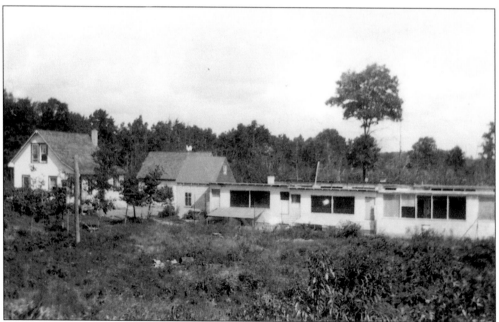

Located immediately behind the house were the chicken coops that housed the Turschmann family's flocks. Today, Vineyard Road is anchored at its north end by Costco and Westinghouse and at its south end by the Ford Motors truck assembly plant. The Westinghouse plant was constructed on the Dawson farm. (Dorothy Turschmann.)

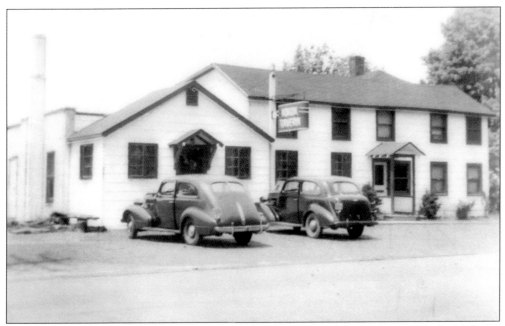

Knox's Tavern on the Lincoln Highway at Bridge Street was a favorite watering hole. Nicholas Knox was awarded a liquor license in 1939, the year this photograph was taken. At one time, the establishment was named the Beech Tree Inn. The Lincoln Highway, also designated in Edison as Route 27, was part of the first transcontinental highway in the United States. (Nick Cotton.)

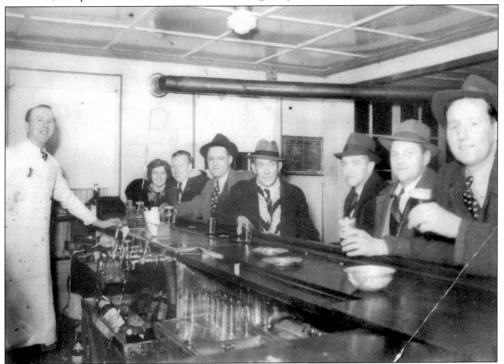

A cheerful crowd enjoys their glasses of beer at Knox's Tavern in this undated photograph. The Knox Package Store is now located on the Lincoln Highway site, adjacent to Interstate 287.

Fellheimer & Wagner Architects designed the Johnson & Johnson Shipping Center, which was constructed by Rule Construction in 1949 at Route 27 and Talmadge Road. Revlon acquired the building in 1956 and expanded it in 1959, as shown here. The Revlon office building and the Edison post office were later constructed on the lawn area at right. Portions of the complex were recently demolished. Route 27 between Talmadge Road and Interstate 287 was known as the "Miracle Mile" during the 1950s, due to the township successfully attracting Johnson & Johnson, RCA, and Westinghouse to the area. The nearby Ford Motors truck assembly plant, located at the southern end of Vineyard Road at U.S. Route 1, was constructed in 1948. In the photograph, Route 27 is visible in the foreground and Talmadge Road is visible at left. The northeast corridor railroad for Amtrak and New Jersey Transit is visible in the background. Pines Manor, with its swimming pool out back, is partially visible in the foreground.

Six

ROOSEVELT PARK AND CLARA BARTON

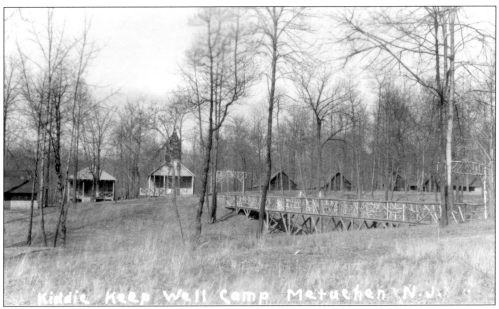

Located adjacent to Roosevelt Hospital and Roosevelt Park, Kiddie Keep-Well Camp was established in 1924 for children diagnosed with tuberculosis. Seen here in 1932, the camp changed its focus over time and now serves economically disadvantaged children of Middlesex County. Children visit the camp for two-week intervals during the summer and receive dental and medical check-ups during their stay.

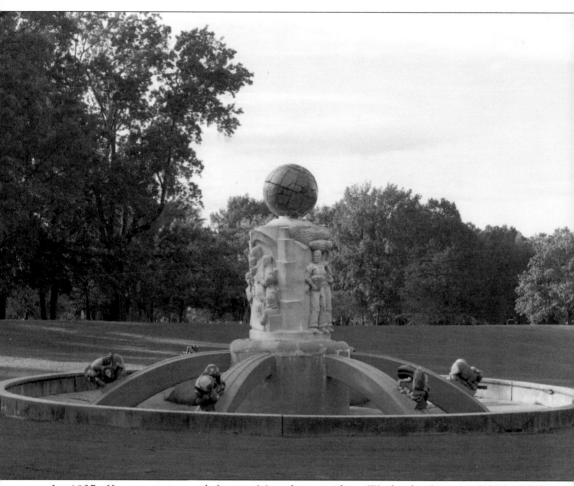

In 1937, Kansas native and former Metuchen resident Waylande Gregory (1905–1971) completed his concrete and ceramic sculpture entitled *Light Dispelling Darkness* for installation in Roosevelt Park, near Woodbridge Avenue and U.S. Route 1. Gregory served as director of the New Jersey Federal Arts Project of the Works Progress Administration (WPA). The currently nonfunctional 15-foot-high fountain features a ceramic globe, representing Earth, atop a concrete shaft. As depicted in relief on the shaft, the work represents, in the words of the artist, man overcoming the forces of evil through knowledge, discovery, invention, and applied science. The six wings support symbolic figures representing the forces of evil: greed, materialism, and the Four Horsemen of the Apocalypse (Pestilence, War, Famine, and Death). The figures were originally partially submerged in water at the base of the fountain. The location of the work also pays respect to the nearby site of Edison's invention of the incandescent lightbulb. Sadly, the piece has deteriorated and the heads of the brightly colored figures have been vandalized. (Photograph courtesy of Douglas Petersen.)

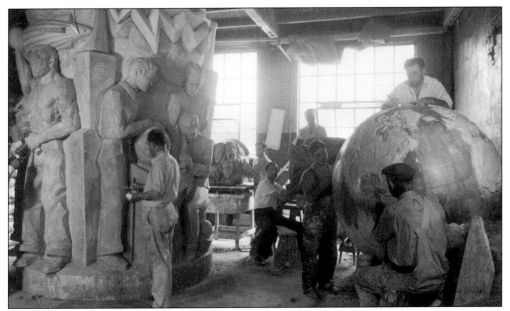

This 1937 WPA studio photograph shows Gregory's assistants working on the piece, which took a year to complete. The shaft is visible at left and the globe is visible at right. The figure in the background appears to be Pestilence. Gregory taught at the Cranbrook Academy of Art in Michigan during the Great Depression and established a workshop at the Atlantic Terra-Cotta Company in Perth Amboy in 1933.

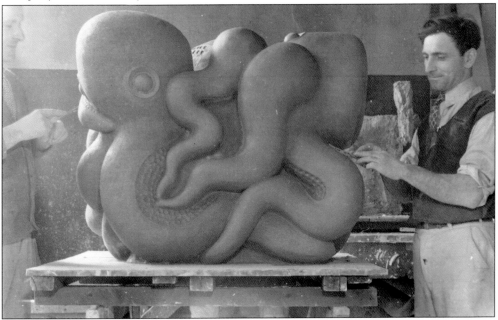

Two unidentified assistants are seen here working on the Greed figure. Gregory's assistants included Amadeo Lovi, Henry Lovi, Adolph Maffai, Ned Monti, William Deuel, Andrew Petrovitz, and John Corolla. Gregory built a home in Warren, New Jersey, in 1938, where he lived with his wife until his death. In 1939, he designed the 60-foot-high *Fountain of the Atoms* at the entrance to the New York World's Fair, which was later dismantled.

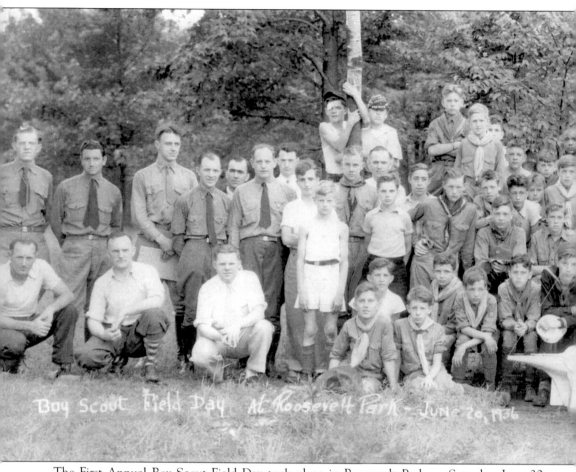

Boy Scout Field Day At Roosevelt Park – June 20, 1936

The First Annual Boy Scout Field Day took place in Roosevelt Park on Saturday, June 20, 1936. Participating troops were Raritan Township Troops 12 and 14 and Metuchen Troops 14, 15, and 16. Events included the shot put, the running broad jump, the standing broad jump, the baseball throw, the 50-yard dash, the 100-yard dash, and the potato race. The meet was followed by the third annual model yacht race, organized by the Sea Scouts division of the Boy

Scouts. Winners from Raritan Township included Paul Loman of Troop 15 in the under-12-inch boat race; Allan Sleight of Troop 15 in the 12-to-25-inch boat race; and William Ainslie of Troop 14 in the open-class race. The officials were Jack Reynolds, Charles Ellingwood, Warren Carlsen, Fred Cordery, Joseph Donahue, Sam Wiley, William Pick, and Donald Lawrence. (Courtesy of Rita Halpin and Jim Halpin.)

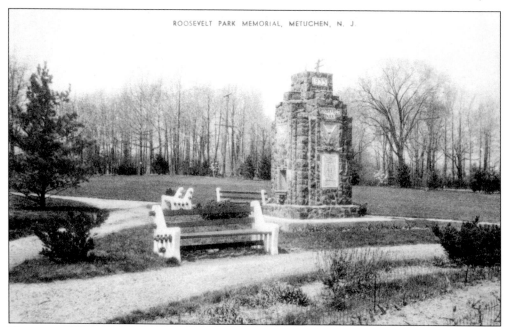

The stone monument facing U.S. Route 1 was erected in 1933. The white ceramic plaque reads, "Dedicated to the men of Middlesex County who donated their labor to develop this park in exchange for the benefits of relief received—Emergency Relief Administration [ERA] of Middlesex County, Lewis Compton, Director." Blue ceramic eagles are located on each side. The two water fountains it contains are no longer operational.

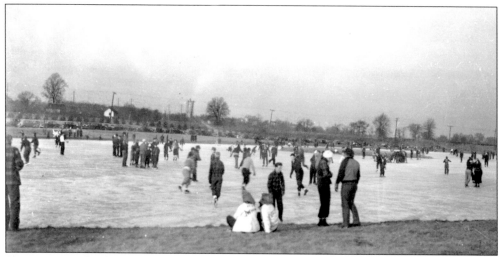

Skaters enjoy the frozen lake at Roosevelt Park in this view looking northeast. The park's builders created the lake for recreational use. The 192-acre Roosevelt Park was created in 1933 by WPA and ERA workers, who cleared underbrush and filled marshland to create the landscape visible today. The park was the first installment of the Middlesex County Park System.

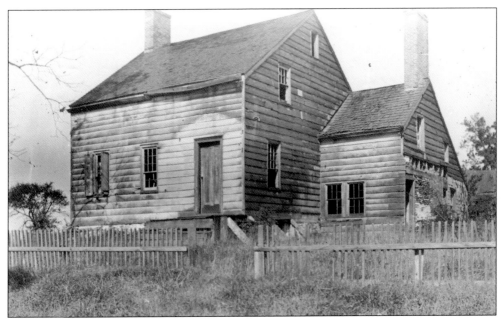

The 18th-century W.C. Sage House was located on the north side of Lafayette Street near the present-day Roosevelt Drive entrance to Roosevelt Park. The house had been abandoned by the time of this undated photograph. An addition had been removed from the right exterior wall, exposing the back of the brick chimney and original wood shingles at the rear. Notice the wood gutters on the front of the house.

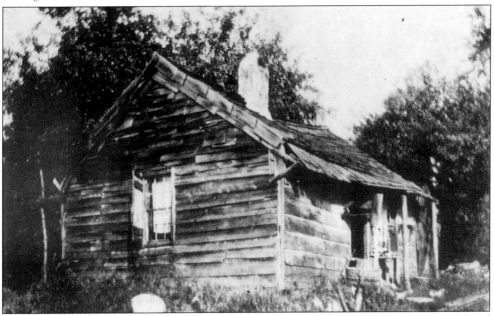

Lafayette Schoolhouse No. 16 was located at the northeast corner of Parsonage Road and Lafayette Road (formerly named Woodbridge Road), near the U.S. Route 1 end of the Menlo Park Mall parking lot. The school district was consolidated with the Uniontown (later Menlo Park) district. The construction of several new township schools in the early 1900s made this building obsolete. By the 1920s, it had been abandoned.

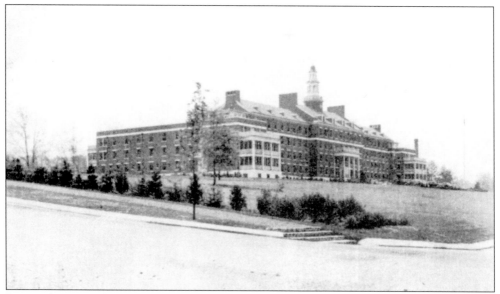

Roosevelt Hospital, originally the Middlesex County Tuberculosis Hospital, was designed by architect John Noble Pierson. President Roosevelt's New Deal PWA programs funded the project, and the completed building was dedicated in 1936. Located today amid heavy traffic heading to the Menlo Park Mall, the site was initially chosen for its relative remoteness, as was the standard of the time due to the contagious nature of tuberculosis.

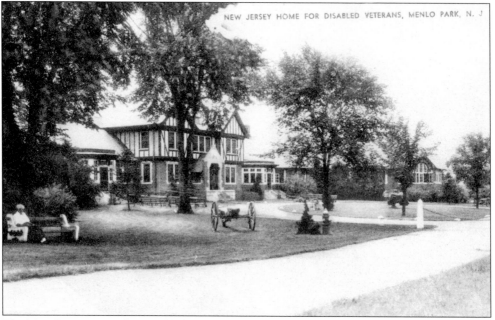

The New Jersey Home for Disabled Veterans was established in Kearny in 1866 for veterans of the Civil War. One Civil War veteran was still under their care in 1937. The home, today one of three veterans' nursing homes in New Jersey, moved to its present location on 150 acres near Roosevelt Park in 1932. Portions of the facility were recently demolished and new residential units were constructed in 1999.

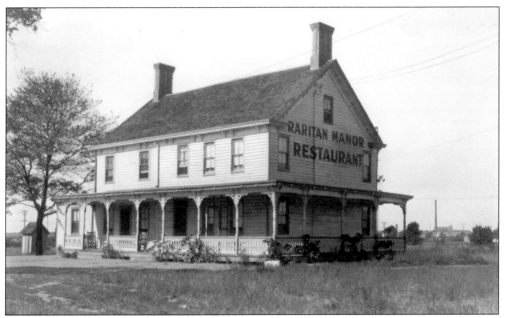

This handsome Italianate-style house, shown in 1932, is reported to have been owned by the Pfiffer family. More interesting is the advertisement for the Raritan Manor Restaurant painted on its side. The house, which is no longer standing, may have been located on Amboy Avenue where the New Jersey Turnpike is now located.

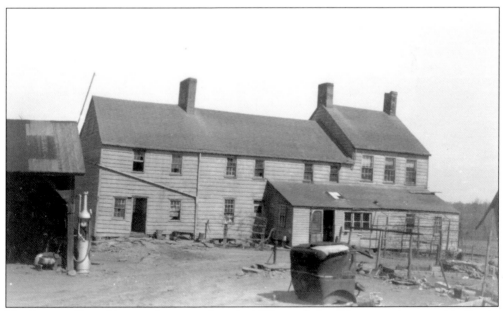

The Raritan Township poor farm, seen here in 1933, was located just over the township line in Woodbridge. The forlorn farm, established before 1875, was located at the southern end of Poor Farm Road, which was an extension of Wood Avenue. The Metropark office buildings are now located on the site of the farm. Notice the discarded rear half of a carriage in the foreground.

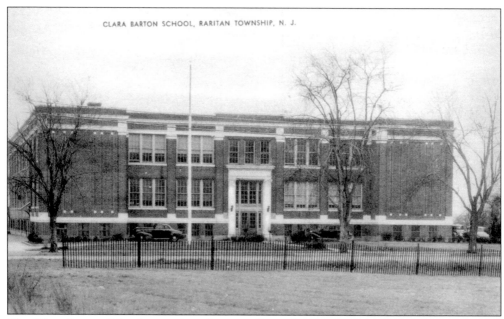

The Clara Barton School opened its doors on December 14, 1921, to 300 students in grades on through six. The Board of Examiners rated the school the best in the county in 1924. By 1925, the school was filled to capacity. Two wings and the auditorium were added in 1929 to accommodate the increasing number of students. Declining enrollment and the age and condition of the school building prompted its closure on June 25, 1984.

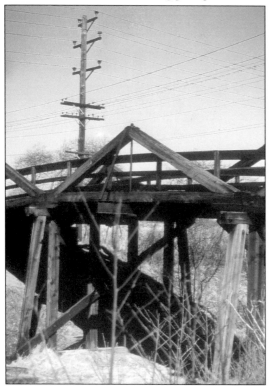

The one-lane Pierson Avenue Bridge, photographed in April 1959, was replaced in 1999. The bridge experienced ever increasing traffic because it provided a shortcut from Amboy Avenue and the Tano Mall to U.S. Route 1. The bridge was familiar to many because drivers always had to stop and honk the horn to make sure no one was coming from the other direction. (Bill Ainsley.)

Seven

OAK TREE
AND PUMPTOWN

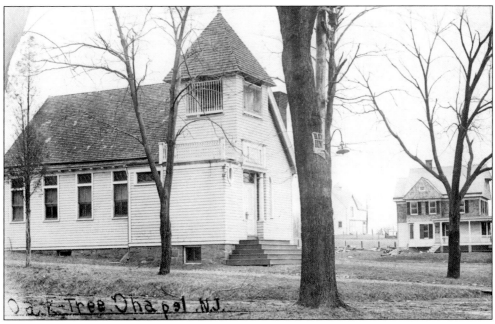

This postcard of the Oak Tree Chapel was taken in 1916. The chapel, also known as the Marconnier Union Chapel, was constructed in 1895 at the northeast corner of Oak Tree Road and Woodland Avenue. Orvalle Freeman's house and W.E. Van Court's barn are visible in the background. The building now houses the Edison Valley Playhouse. The Freeman house, though altered, is still located east of the chapel.

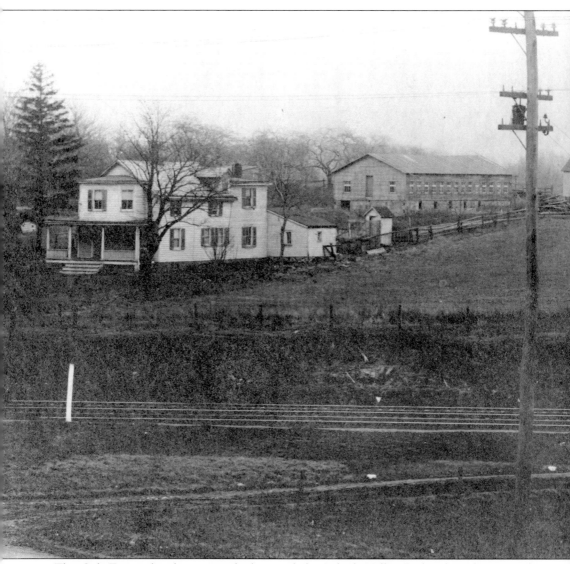

The Oak Tree railroad station, which served the Lehigh Valley Railroad, is shown in this
c. 1915 photograph by A.E. Hickman of Plainfield. The station was located on the south side
of Oak Tree Road, west of the Plainfield Avenue and Tingley Lane intersection. Construction
of the Easton and Amboy Railroad, which later became the Lehigh Valley Railroad, began in
1872. However, this branch, which continues on to Potters Crossing, was not completed until

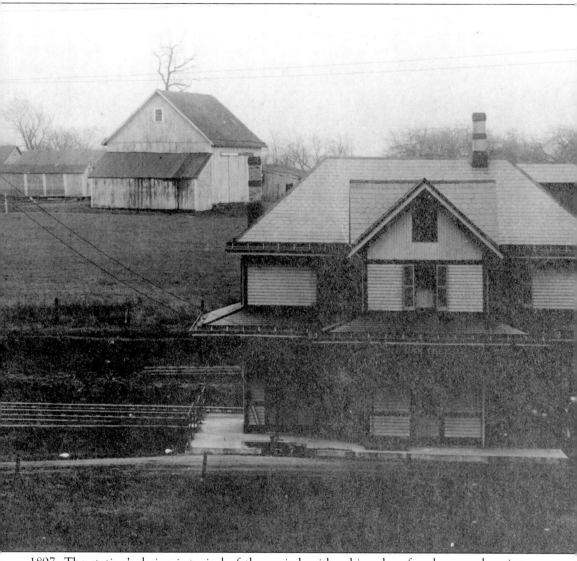

1897. The station's design is typical of the period, with a hipped roof and an overhanging shelter on all sides. Stations of this time often had a second floor in order to provide living quarters for the stationmaster and his family. The E. Van Court farm is seen across the tracks in the background. The dirt road partially visible in the foreground is Oak Tree Road.

An unidentified woman poses with her pony and cart outside a farmhouse on the west side of Tingley Road. The house is said to have originally been owned by farmer Noah Mundy, and later, after Mundy moved to Metuchen, the property was known as the W.M. Tappen or Tingley Farm. The house burned at an unknown date.

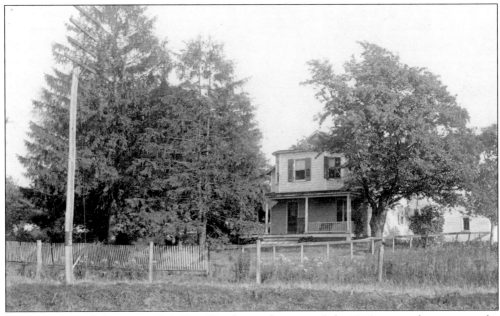

Mary Van Court's house on Oak Tree Road, seen here in a July 1916 postcard, appears to be what is now 144 Harding Avenue (see pages 86 and 87). The Van Court family lived in this house for several generations. The name E. Van Court appears on the 1850, 1876, and 1887 maps of the area. (Courtesy of Walter Stochel Jr.)

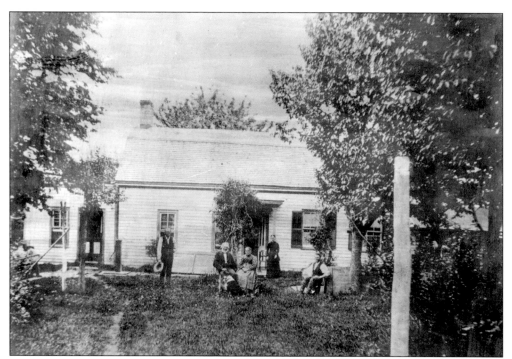

A family poses outside the Clarkson-Noe house in Oak Tree. The J.C. Noe house was located on the north side of Oak Tree Road, west of Plainfield Avenue on the 1876 map of the area. Although this 1933 photograph is attributed to J. Lloyd Grimstead, the family's dress and the style of the photograph appear to be from several decades earlier. Perhaps it is a photographic copy of an earlier photograph.

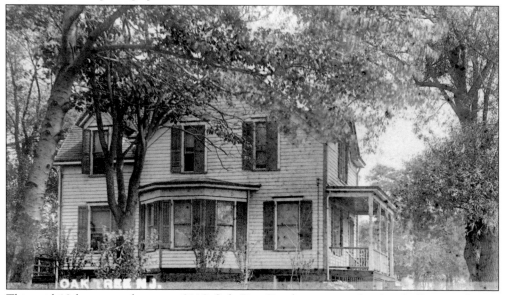

This mid-19th-century house at 2110 Oak Tree Road appears to be the A. Freeman house, which is included on the 1882 map of the area. The house is located on the north side of Oak Tree Road across from Alpine Street. The porch has since been removed and replaced with a Colonial Revival portico supported by triangle brackets.

The Oliver Kelly house was located at the northeast corner of Oak Tree Road and New Dover Road. Although the house is no longer standing, the site is said to have hosted one of the Revolutionary War skirmishes during the Battle of Short Hills on June 26, 1777. As soldiers marched toward the contested Watchung Mountains, a series of skirmishes took place between Metuchen and Plainfield.

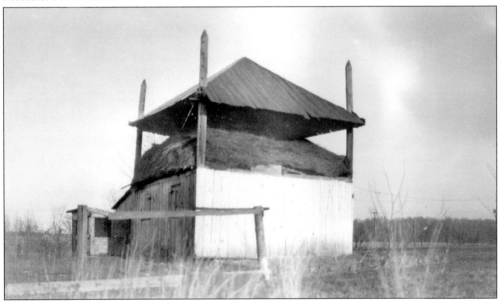

The Kelly farm hay barracks were used to store hay. The roof was raised or lowered along the corner posts, depending on how high the hay had been stacked. Hay barracks, which are now a rare sight anywhere in New Jersey, were still in use at the time of this 1933 photograph, attesting to how recently farming was still a way of life here.

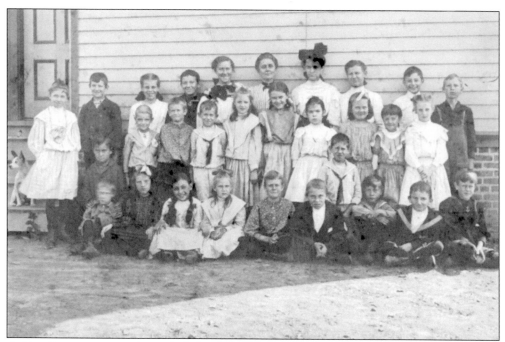

A friendly pup wants to be included in the Oak Tree School class photograph. The dog is at the far left on the steps next to Marion Silence, the only child identified in the photograph. Teacher Susan Fillips, back row center, came to Raritan Township in 1892 to teach in the Oak Tree School. She later taught at the Sand Hills School, from 1912 to 1921.

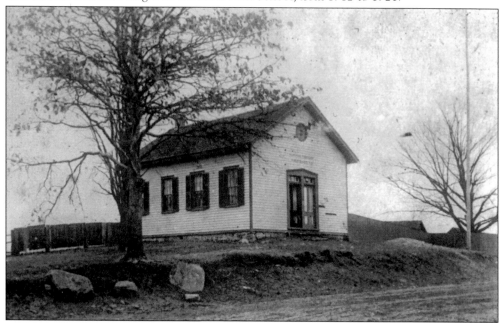

Oak Tree School No. 6, seen here before 1909, was sold to Myra Biggs, a teacher and principal at the school, when the new school was constructed. She converted the building, still located at the southeast corner of Plainfield Avenue and Oak Tree Road, into a house. The former alignment of Oak Tree Road is visible in the foreground.

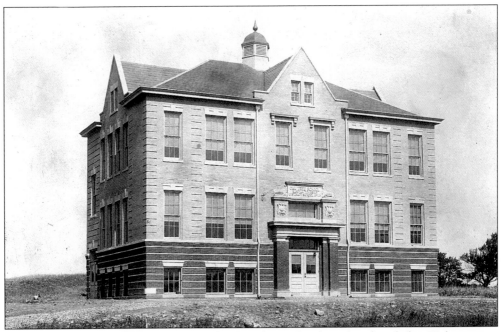

The secession of Metuchen and Highland Park in the first decade of the 20th century suddenly left the township without two of its most heavily used schools. Two new schools were constructed to help fill this need: the Bonhamtown School in 1908 and, pictured here, Oak Tree School No. 6 in 1909. The building is now in use by the JFK Johnson Rehabilitation Institute as an outpatient rehabilitation center.

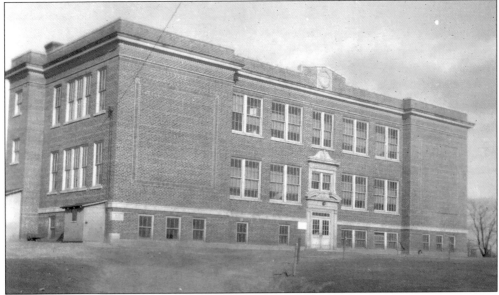

Oak Tree School No. 6, shown here c. 1940, was dramatically altered in 1923 with the removal of the gable roof, the relocation of many windows, and the addition of two brick wings to the east and west. Compare this photograph with the "before" photograph above. As a reflection of this major change, there are two date stones located in the southwest corner of the building. (Courtesy of Walter Stochel Jr.)

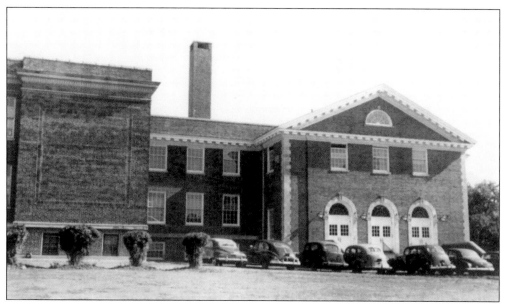

A large addition on the eastern end of the Oak Tree School was completed in September 1951 and photographed the following year. After World War II, new schools were needed for children born during the postwar years. During the 1950s, Stelton School was also expanded, Washington School and Lincoln School were constructed, and the junior-senior high school was completed.

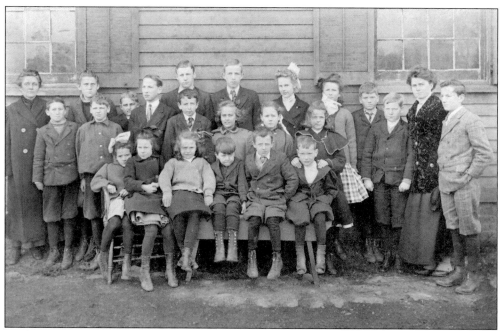

Students of the Oak Tree School (see page 91) brave blustery winds on a pre-1909 picture day. Oak Tree Road was originally located on the south side of the school. The road was realigned in 1929 to run behind the building to the north, leaving the building on a pie-shaped piece of land. The building was later altered and now contains a realtor's office.

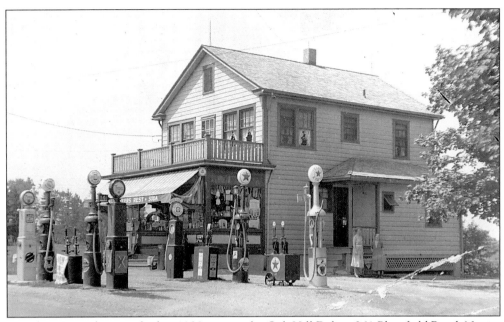

Traveler's Rest, photographed in 1930, is now the Oak Hill Deli at 261 Plainfield Road. Notice the two women standing by the side porch. The village of Oak Tree derived its name from an oak tree located next to the schoolhouse at the intersection of Plainfield Road and Oak Tree Road, which was known as "the road to Uniontown" in the 19th century.

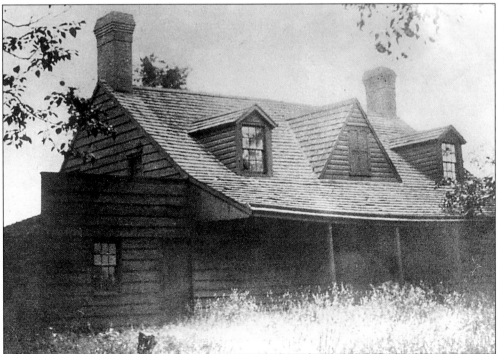

The N.R. Compton house, shown c. 1903, was located on the south side of Park Avenue near the end of what is now Colonial Court. Pumptown, also known as Pumptown Corners, is the area near the intersection of Plainfield Road and Park Avenue, south of Oak Tree. (Bill Smith.)

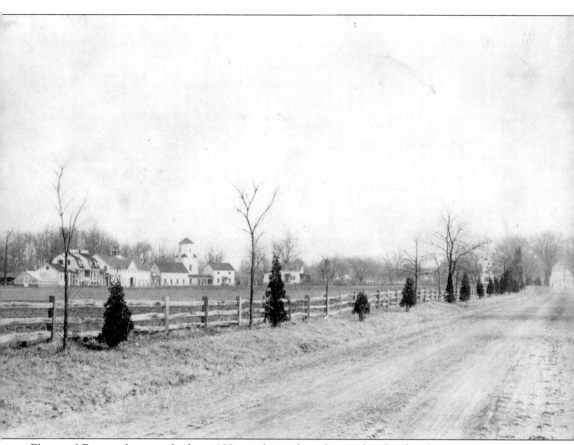

Elmwood Farms, photographed in 1923, was located on the north side of Park Avenue between Plainfield Road and the bend. Farm workers lived and ate at the boardinghouse at the left. The main house, which is still standing at 4001 Park Avenue, is visible at the roadside, amid the trees at right. A second farmhouse, still standing at 294 Central Avenue, is visible in the distance at the end of the road. Horace Williams, owner of Elmwood Farms, had an elegant Neoclassical-style estate on Park Avenue near the farm. The area now looks quite different, with many houses filling this land and the addition of mature trees among the houses. Through the 1950s, the south and west sides of Park Avenue near the bend had remained farmland. By the 1960s and 1970s, the farms were subdivided and houses were constructed on Elmwood Farms and Wood Brook Farms. Also at that time, the west side of Park Avenue between the bend and Nevsky Street was developed into an industrial park with warehousing and office space.

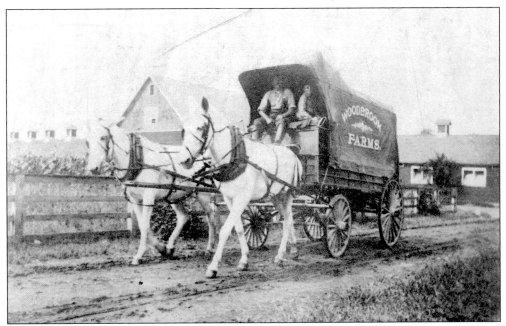

The Wood Brook Farms wagon is shown bringing milk to market *c.* 1888. The large dairy farm was located at the bend in Park Avenue, where the Woodbrook Corners development is now located, and reached west into the Dismal Swamp. The farm was managed for many years by W.R. Hale, who later became a county freeholder. Shando Vinez, seated next to his father in the wagon, later worked at the farm. (Courtesy of Walter Stochel Jr.)

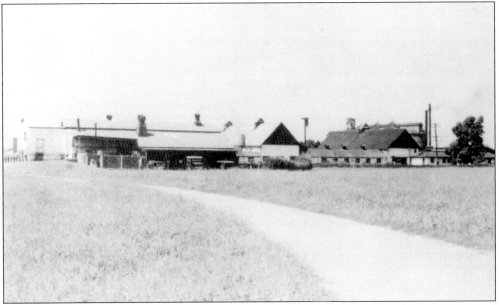

Wood Brook Farms, seen here in 1938, was established in 1906. By 1922, the dairy delivered milk to 150 cities and towns. Promotional materials from the 1920s assuaged the fears of tuberculosis, a disease communicable through milk, by extolling the cleanliness of the facility. To prevent disease, employees and cows alike underwent weekly medical exams, and the cows, employees, and buildings were scrubbed before milking.

Eight

NEW DOVER, POTTERS CROSSING, AND NORTH EDISON

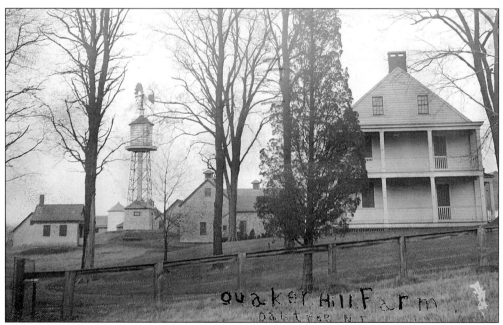

A.E. Hickman took this postcard view of the Quaker Hill Farm near Oak Tree in 1911. This appears to be another view of the Laing House (see page 98). Five outbuildings, a windmill with a cistern, and a silo are visible in the background. The barn is still standing. This is one of three Laing farmhouses on Woodland Avenue.

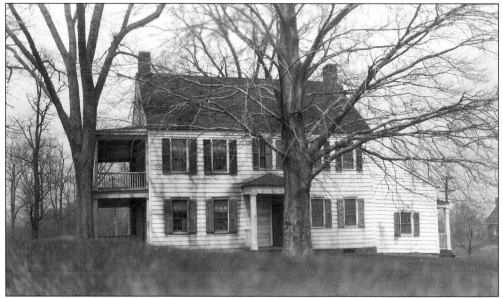

The Laing House, located at 1707 Woodland Avenue, is listed on the National Register of Historic Places. The house is significant because it represents the early settlement of the area by Scottish Quakers. It was part of the Plainfield Plantation, which the Laing family acquired in 1689. The house is thought to have been constructed during the first quarter of the 18th century and was renovated in 1946. It is shown here in April 1933.

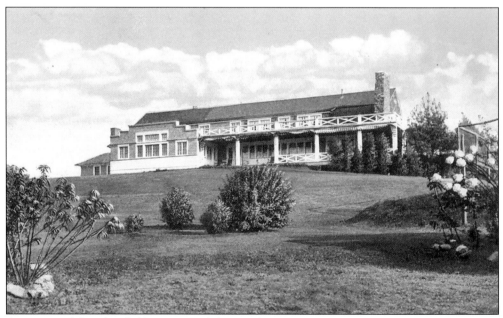

A portion of the Plainfield Country Club, seen here in a 1919 postcard, is actually located in Edison on the east side of Woodland Avenue, just south of the Maple Avenue/Old Raritan Road intersection. The club was established in 1890 and the Scottish-born Donald Ross (1872–1948) laid out the golf course in 1916. Ross is credited with the design of approximately 400 golf courses in the United States.

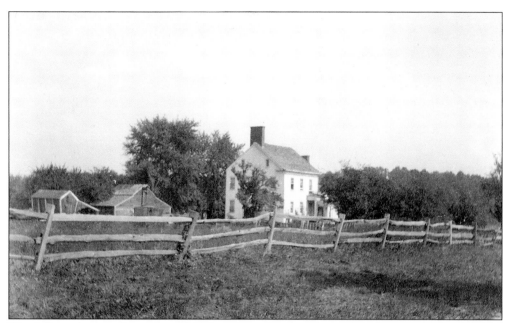

The J. Force house is located at 806 New Dover Road at the northeast corner of the Stratford Lane intersection. The wide-open farmland and dirt road in this 1902 photograph evoke a very different image than does the modern housing development that now fills this view. At the far left is a corncrib and at center is a small barn with two shed additions. (John Brinckmann.)

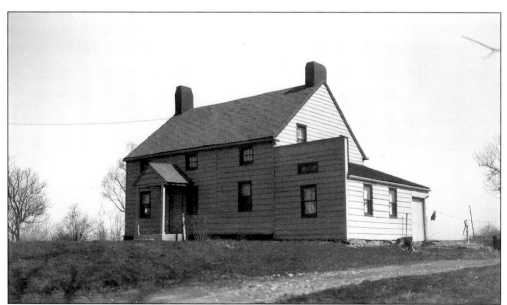

The A. Blackford house is located at 1105 New Dover Road on the south side of the road. The flat front of the wing at the right has been removed and a two-story wing has been added to the rear of the house; however, the house still retains much of its early appearance. The setting has changed with the construction of houses and the widening of the road, which brings the road much closer to the front door.

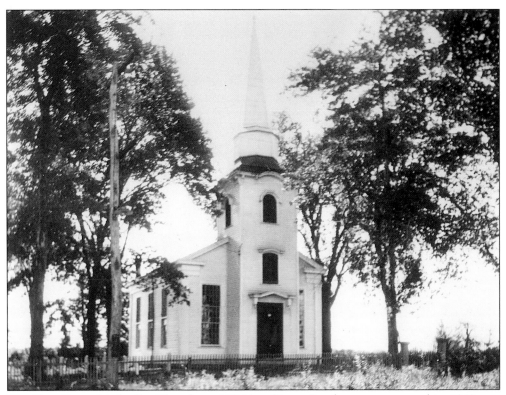

The New Dover Methodist Church, at 690 New Dover Road, was constructed in 1849 at a cost of $2,700 on land donated by Gussie Wood. After Rev. J.R. Adams was sent here in 1850, families no longer had to attend services in Rahway and Woodbridge. Electricity was added just four years before this 1928 photograph was taken. The steeple was replaced in 1930.

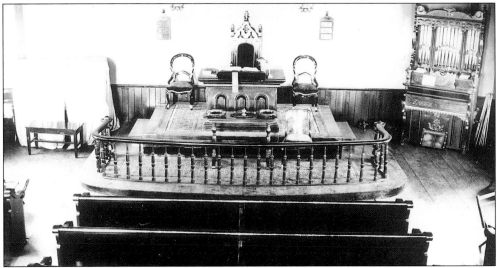

The interior of the New Dover Methodist Church is seen here in 1928. A rural community well into the 20th century, New Dover was described in 1882 as a small settlement with one store, the church, New Dover Schoolhouse No. 12, and a post office. At the time of the building's construction, there was a membership of 18 people.

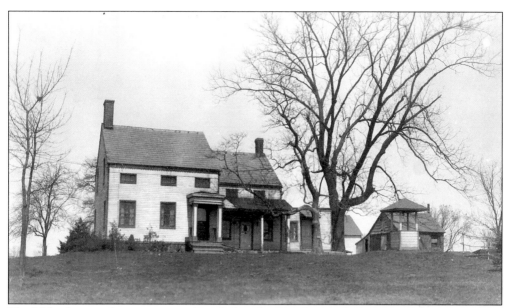

The Hyler house, also sometimes identified as the Huick or Hyke house, still stands amid tall trees on the east side of Grove Avenue, just north of the New Dover Road intersection. Seen in a 1933 J. Lloyd Grimstead photograph, this late-18th- or early-19th-century house features a diminutive bargeboard, also known as "gingerbread" detailing, on the left-hand section of the building. The well in the front yard is still standing.

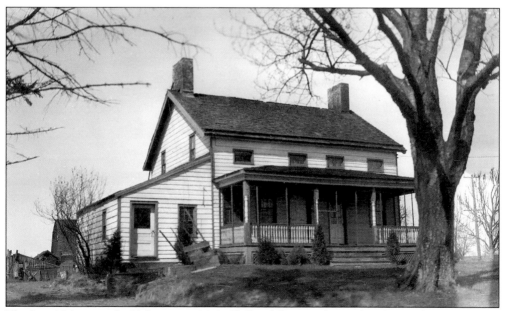

The late-18th- or early-19th-century N.C. Philbrick house is located at the northwest corner of New Dover Road and Grove Avenue. A large barn, outbuildings, and a greenhouse are visible in the background. The building has been altered from its 1933 appearance, seen here, with orange brick facing and the addition of a front portico. A smaller barn and the greenhouse frame are still standing.

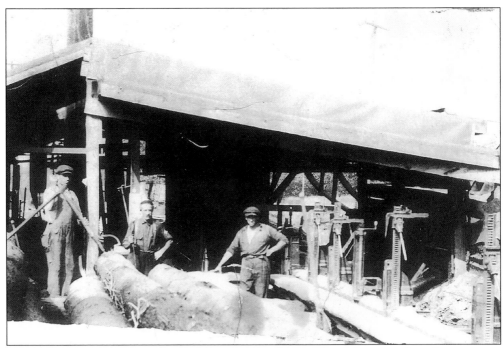

The men at Ten Eyck's sawmill at Oak Tree Road and Grove Avenue stop working for a moment to pose for this 1930s photograph. The men are identified on the back of the photograph, from left to right, as Pete, "Old Pete," and James "Dutch" Wilton, the father of Jim Wilton. (Jim Wilton.)

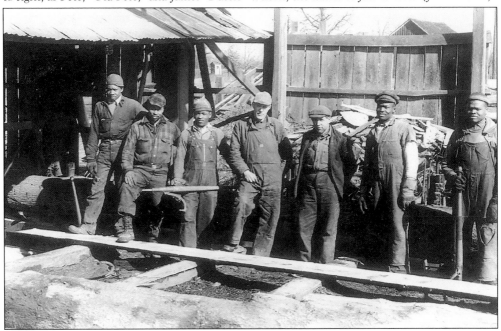

The workers at Ten Eyck's sawmill are pictured in 1942. They are, from left to right, unidentified, Joe Watson, ? Perry, Harry Ten Eyck, James "Dutch" Wilton, and two unidentified men. Matthias Ten Eyck was a lifelong township farmer. In the 1920s, his farm was the largest in the township. He and his wife, Ida, had two sons, Edward and Harry Ten Eyck. (Jim Wilton.)

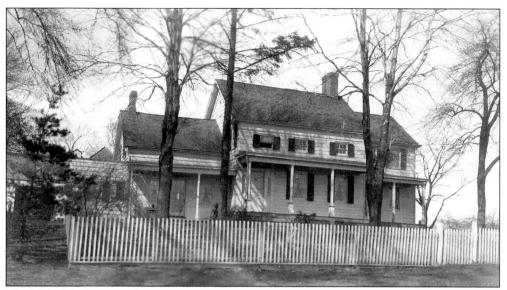

The Melick house, seen here in 1933, is still standing at 1220 Inman Avenue, just west of the Tingley Lane intersection. The area around this intersection was generally known as Mount Pleasant and, as recently as the 1950s, Tingley Lane was named Mount Pleasant Road. West of Tingley Lane, Inman Avenue was called "the road to Mount Pleasant Schoolhouse." East of Tingley Lane, it was named Rosalind Avenue.

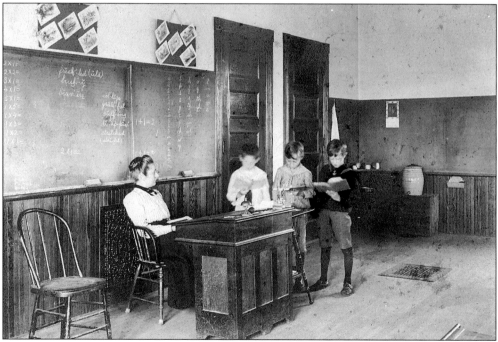

Three students show their teacher, Susan Fillips, how well they have practiced their lessons. This undated photograph is probably the Mount Pleasant School No. 11, located on the southeast corner of Tingley Lane and Inman Avenue, or perhaps the Oak Tree schoolhouse. Fillips taught at Mount Pleasant from 1904 to 1907. From 1921 until 1924, she taught at the Bonhamtown School.

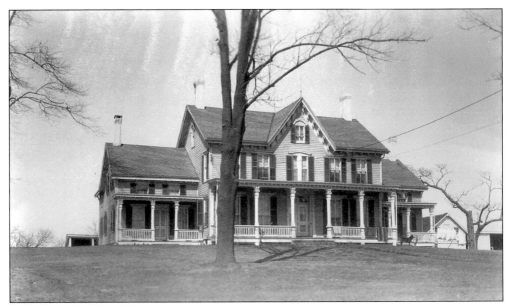

The J.R. Potter farm was the namesake for the railroad crossing adjacent to the farm. His Italianate-style house, seen here in a 1933 J. Lloyd Grimstead photograph, once commanded the north side of Inman Avenue midway between Rahway Road and Grove Avenue on the site now occupied by the West Gate housing development. Note the outbuildings behind the house, which indicate the property was still in agricultural use.

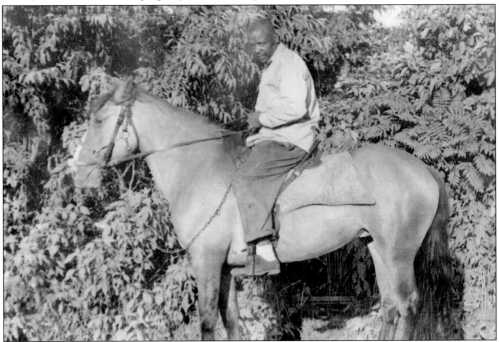

Within the rural character of Potters Crossing, horses would not have been out of place. The entire community was razed beginning in the 1960s as part of an urban renewal project that resulted in the Inman Grove Shopping Center, senior citizens housing, and a housing complex at the intersection of Inman and Grove Avenues.

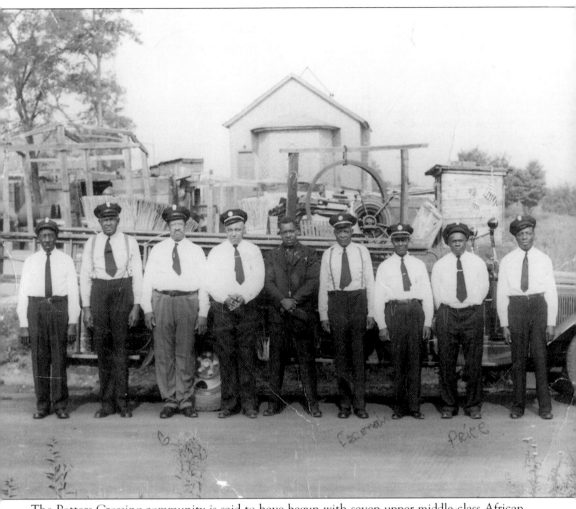

The Potters Crossing community is said to have begun with seven upper-middle-class African American families from Harlem who moved here in 1917. Beginning in the 1920s, Potters Crossing attracted African American men from the south who were seeking work and a better life for their families amid the farmland of northern Raritan Township, as Edison was then known. By the 1950s, the community, which was centered on the intersection of Grove Avenue and Inman Avenue, had grown to include three churches, civic associations, restaurants, candy stores, homes for 1,500 residents, and a volunteer fire department, seen here in an undated photograph. Only two of the men are identified: Ferman? is sixth from the left and Price is eighth from the left. A local baseball team was organized and residents played semiprofessional black teams from Newark and Jersey City. After the community was razed, few residents were able to relocate nearby and many left the area. (John Richardson.)

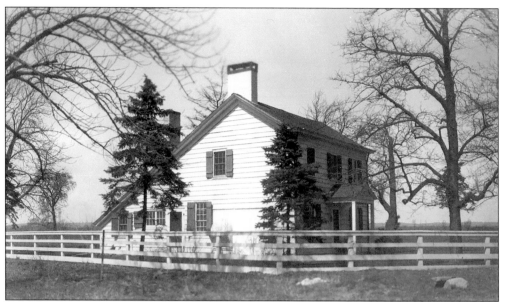

Only ruins of the *c.* 1740 Beehive Oven House, as it is commonly known, remain at the north end of Featherbed Lane at the township line. The house was moved *c.* 1800 to its present location on Homestead Farm, now Oak Ridge Golf Club, for use by a tenant farmer. The house was included in the Homestead Farm listing on the National Register of Historic Places.

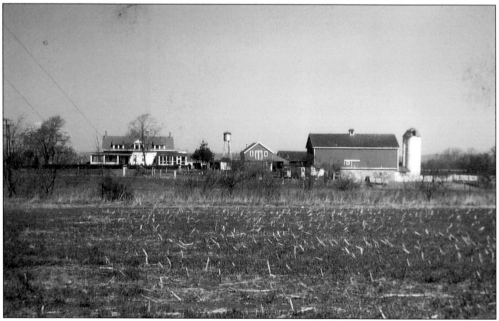

Well into the 20th century, Raritan Township was a collection of small crossroads communities with large expanses of farmland in between, like this typical north Edison farm shown in 1959. The few routes through the area linked the communities to one another. In the early 20th century, the only roads in North Edison were Oak Tree Road, Inman Avenue, New Dover Road, Tingley Lane, Grove Avenue, and Wood Avenue. (Bill Ainsley.)

106

Nine

ON THE ROAD

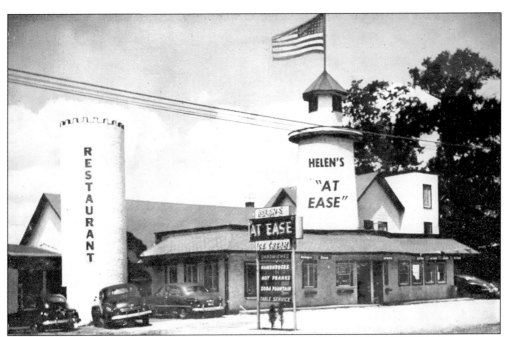

Helen's "At Ease" restaurant, which was located near the site of the Shop-Rite supermarket on U.S. Route 1, was run by proprietors Helen and Dottie. The establishment was later known as the Outside Inn. This postcard boasts that it was "the place that's different." The building burned in 1950 or 1951 and required the rescue of two women from the second floor.

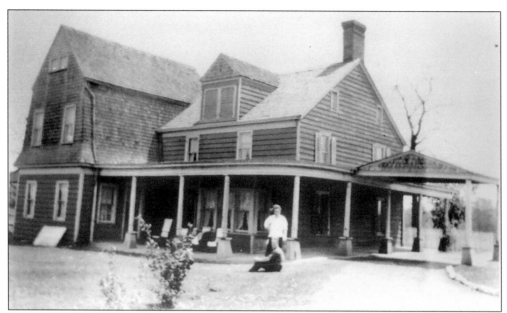

George W. Ainscow Sr. moved to Raritan Township *c.* 1910 from Jersey City. He bought this house, set far back from Route 27, *c.* 1912 and farmed the land. The 18th-century or early-19th-century house (right section) had been updated during the late 19th century with a wing at left, a wraparound porch, and a stylish *porte-cochere* at right that sheltered arriving carriages. (Jane Ainscow Fort.)

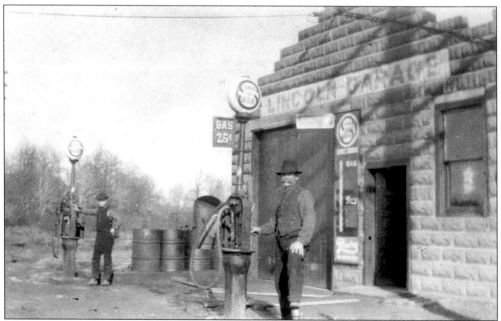

In March 1919, George W. Ainscow Sr. and George Ainscow Jr. pose in front of the Lincoln Garage, which George Sr. had built alongside the Lincoln Highway the previous year. At the same time, he constructed a new house for himself and his family next to the garage and abandoned the first house, seen above. The garage was situated near Fitch Road where Rydel Pontiac stood in 1995. (Jane Ainscow Fort.)

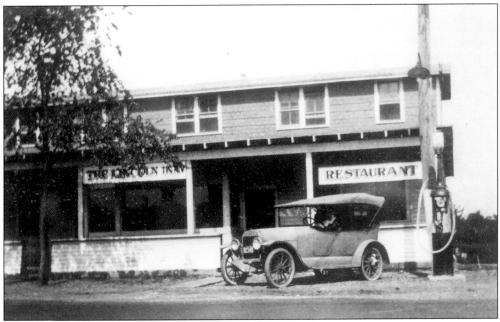

In the early days of the Lincoln Highway, the Lincoln Garage is said to have pumped more gas than any other garage along the route between New York and Philadelphia. Business was so strong that George Ainscow Sr. expanded his holdings and opened the Lincoln Inn across the road from the garage in July 1921. (Jane Ainscow Fort.)

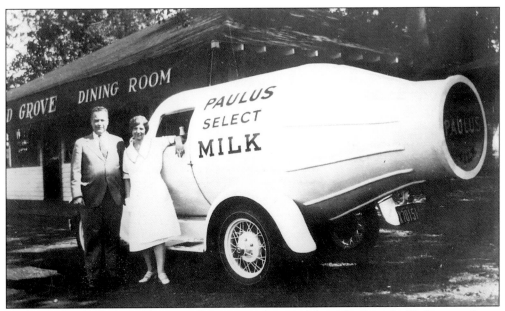

George Ainscow Sr. opened Linwood Grove on the east side of the Lincoln Highway at Stony Road as a hot dog stand in 1924. Ainscow closed the garage and the inn to focus his efforts on his new establishment. In later years, Linwood Grove was operated by his children Roy and Laura Ainscow, parents of Jane Fort. (Jane Ainscow Fort.)

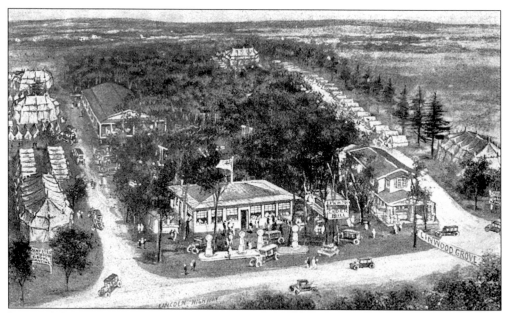

Linwood Grove continued to grow into an amusement park and tourists' camp, as seen in this postcard. Dancing, picnic groves, a gas station, a cider stand, and a campground were among its attractions. The Rossmeyer brothers bought the establishment from the Ainscow family and later sold it to Kovacs, during whose ownership all attractions except the bar were closed. The establishment was destroyed by fire in 1976.

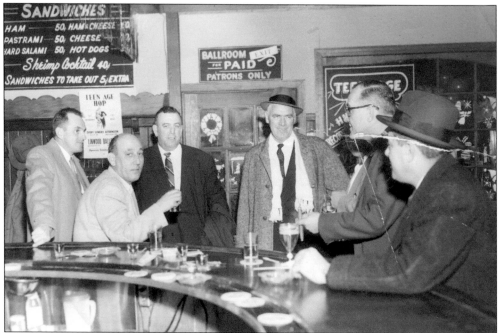

Local Democratic party gatherings occasionally took place at Linwood Grove. George Hollingshead is seated at the bar, left, and Al Grillo is standing third from the left. The other men are unidentified. Linwood Grove expanded to include a banquet hall and was especially busy during the time nearby Camp Kilmer was active. (Courtesy of Walter Stochel Jr.)

The intersection of the Lincoln Highway (Route 27) and Plainfield Avenue is unrecognizably quiet in this c. 1940 photograph. Beyond the cluster of gas stations and stores at the intersection, trees and fields line the road toward Highland Park in the distance. Lois Lebbing's father owned one of the gas stations in the photograph. Notice the ornate lamp posts at the Esso station at left. (Lois Lebbing.)

Twenty years later, the same intersection is still terribly quiet compared to the constant heavy traffic of today. Edward Ottenbine took this photograph at 9:30 A.M. on March 27, 1960, capturing the same view as above. Post–World War II development along Route 27 is visible; the trees and fields have been replaced by commercial establishments well into the distance. (Lois Lebbing.)

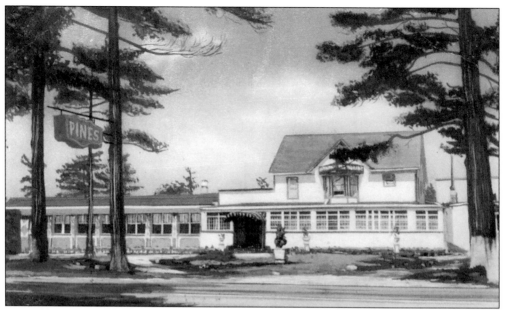

Available open land and consistent traffic along the Lincoln Highway encouraged the construction of commercial picnic groves. The advertisement on the back of this postcard for the Pines reads, "New Jersey's largest and finest supper club . . . one mile from Camp Kilmer. Over 12,000 days of reputable foods (seating capacity 600)." A new building is located at the same location at the intersection of Route 27 and Talmadge Road.

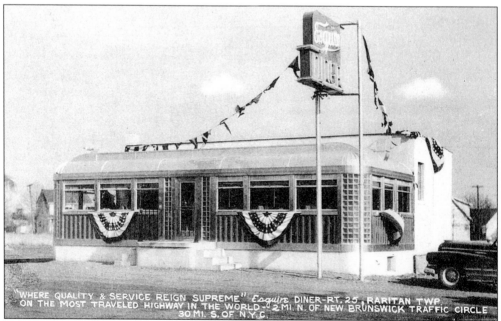

The Esquire Diner, seen here in an undated postcard, looks like the quintessential New Jersey diner. The diner was located "on the most traveled highway in the world," as this postcard boasts. State Route 25 led from Jersey City to Camden. In Middlesex County, Route 25 followed U.S. Route 1 and the Cranbury Turnpike (now Route 130).

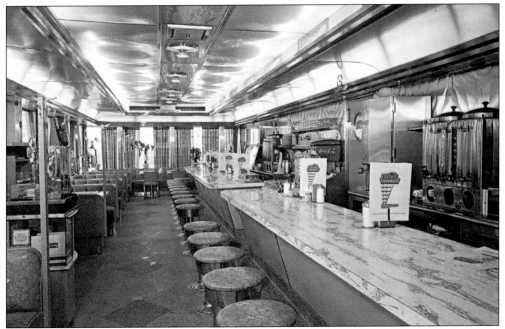

The Edison Diner was located at U.S. Route 1 and Plainfield Avenue. U.S. Route 1 was laid out in the late 1920s, with an official opening in 1930. Merchants on the Lincoln Highway were rightly concerned that U.S. Route 1 would take business from them. After World War II, however, business again began to grow on Route 27.

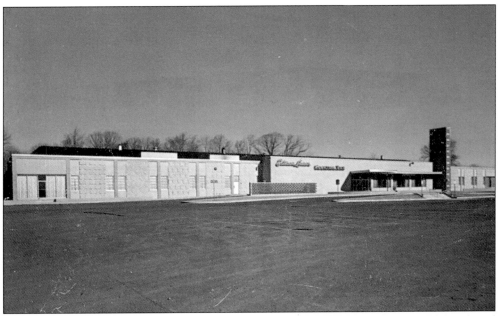

Edison Lanes had the largest number of side-by-side bowling lanes in the world (112) and featured automatic pinsetters. Located at the northeast corner of Plainfield Avenue and U.S. Route 1, the establishment was operated by Jim and Tom Swales. After its closing, the bowling alley was converted into the Wick Plaza Shopping Center.

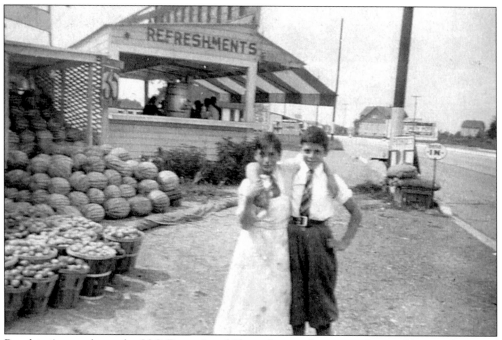

Bocchieri's store, located at U.S. Route 1 and Player Avenue, began as a fruit and live poultry stand in 1935. Two of the Bocchieri boys pose in this undated photograph outside the stand. Notice how few buildings are located along U.S. Route 1. The Bocchieris opened their new store *c.* 1950 and expanded into the nursery and landscaping business *c.* 1955. (Sam and Ann Bocchieri.)

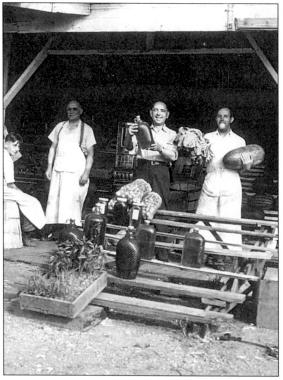

The Bocchieri family has enjoyed owning and operating the establishment, as indicated by the clowning in this undated photograph. Now in its third generation of ownership, the store has recently been renovated by owner Brian Bocchieri, who has welcomed a muffin franchise into the flower and fruit sales business. (Sam and Ann Bocchieri.)

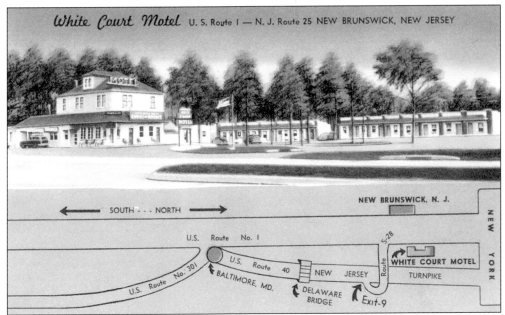

The White Court Motel, located on U.S. Route 1, is still in operation as the Edison Motor Lodge. In its list of amenities, managers S. Kress & Son included the establishment's proximity to the Howard Johnson Restaurant and its 30 modern and comfortable units, each with private shower and bathroom. The inscription on the back of this 1955 postcard reads, "Dear Dad, we are here on our way to visit some friends in Kingston NY."

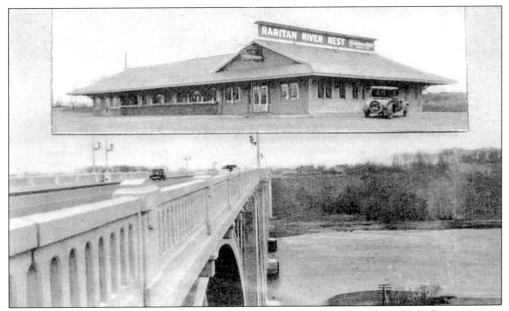

Raritan River Rest, also known as the Green Ball Inn, was located on U.S. Route 1 near the Morris Goodkind Bridge, where Open Road Honda is now located. The 1929 bridge was renamed in 1969 for its designer. Goodkind was chief engineer of the New Jersey Highway Commission and believed that bridges should not only be structurally sound but also beautiful, as is this bridge when seen from the river.

The Garden State Parkway, officially opened in 1954, changed the way we commute and visit the shore. Construction of the first segment between Route 27 in Menlo Park and Central Avenue in Clark began in 1947 and was opened June 28, 1950. Parkway designer and chief engineer Harold W. Giffin also designed the first cloverleaf interchange in the United States, located on U.S. Route 1/9 in Woodbridge.

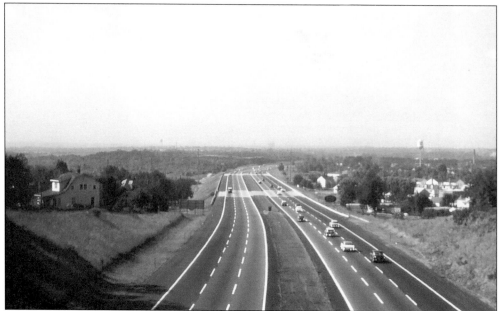

The New Jersey Turnpike in Edison had just three lanes in each direction when it was photographed in October 1958. The third lane was added to the original two in 1955 and has since been expanded to six lanes in each direction. Construction began in October 1950 and the turnpike was officially opened on January 15, 1952. The Exit 10 interchange was opened on January 12, 1970. (Bill Ainsley.)

Ten

IN SERVICE TO
THE COMMUNITY

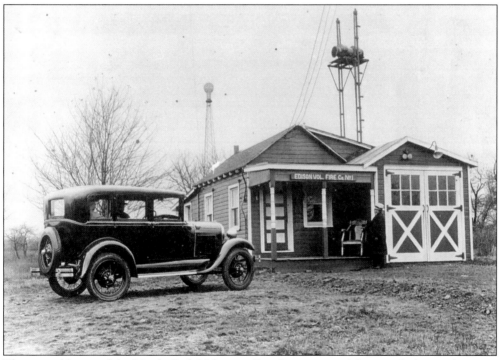

The second home of the Menlo Park Volunteer Fire Company on Monmouth Avenue between Frederick and Christie Streets was purchased from Minnie Clarkson for $500. The company's first location was Thomas Edison's old machine shop on Christie Street. The company moved to the firehouse on Route 27 in 1941. The tower in the distance was constructed in 1929 to commemorate the 50th anniversary of Edison's invention of the lightbulb. (Debbie Stevens.)

The 1922–1923 township committeemen are pictured, from left to right, as follows: (front row) William A. Spencer (attorney), Percival Dixon (committeeman), William A. Kuehl (chairman), Otto W. Wittnebert (committeeman), Wilfred R. Woodward (clerk), and Christian Doll (recorder); (back row) Max Fochtman (tax collector), Charles F. End (committeeman, 1923–1925), David Manning Drake (overseer of the poor), Julius C. Engel (tax collector), John H. Johnson (tax assessor), and George Rush. Peter Knudson was absent. These men made contributions to the community outside the municipal office as well. Woodward was a township teacher for several decades. End was water superintendent from 1929 to 1961. Engel served as township mayor (1931–1935 and 1947–1951) as did Forgione (1951–1955) and Knudson for a partial term in 1930. Engel, Fochtman, Drake, Kuehl, and Woodward were all members of Raritan Engine Company No. 1. Fochtman and Forgione were members of the board of education. A township committee governed the township from 1870 until 1927, with each committeeman serving a one-year term. Each committeeman was responsible for a particular aspect of local government.

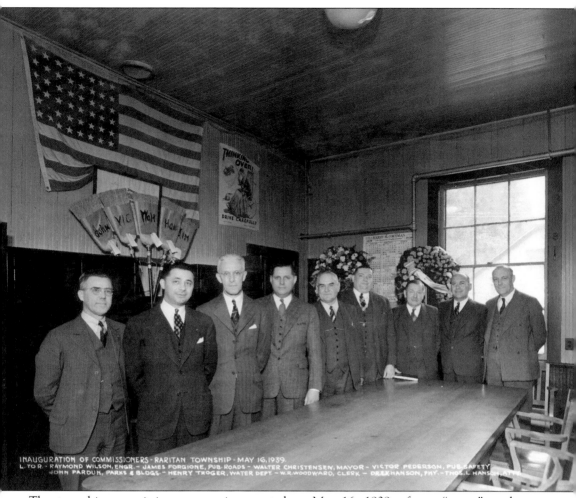

INAUGURATION OF COMMISSIONERS - RARITAN TOWNSHIP - MAY 16, 1939.
L. TO R. - RAYMOND WILSON, ENGR. - JAMES FORGIONE, PUB. ROADS - WALTER CHRISTENSEN, MAYOR - VICTOR PEDERSON, PUB. SAFETY - JOHN PARDUN, PARKS & BLDGS. - HENRY TROGER, WATER DEPT. - W.R. WOODWARD, CLERK - DR. E. HANSON, PHY. - THOS. L. HANSON, ATTY.

The township commissioners were inaugurated on May 16, 1939, after a "sweep" at the polls. Pictured, from left to right, are Raymond Wilson (engineer), James Forgione (public roads), Walter Christensen (mayor), Victor Pederson (public safety), John Pardun (parks and buildings), Henry Troger (water department), W.R. Woodward (clerk), Dr. E. Hanson, and Thomas L. Hanson (attorney). Christensen was township mayor from 1937 to 1947. Forgione was the cofounder of the Forum Theater in Metuchen. In 1928, the government was changed to the commission format, in which the commissioners were chosen by popular vote. The commissioners chose the mayor from among themselves, typically awarding the job to the one who garnered the most votes during the election. In 1958, the council form of government was chosen and the mayor and council members were chosen via general election.

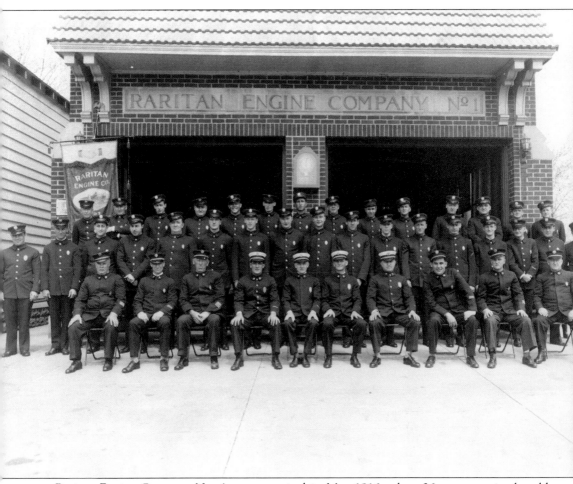

Raritan Engine Company No. 1 was organized in May 1916, when 26 men met in the old town hall behind St. James Episcopal Church and formed a volunteer fire department to serve Piscataway, Nixon, Bonhamtown, Lindeneau, and Stelton. Two weeks later, 18 additional men joined, creating a charter membership of 42. Each man was to purchase his own pail; additional pails were purchased by the company to be placed in boxes hung on poles in the neighborhood. When answering an alarm, each member was to bring his pail and gather any pails he passed on his way to the fire. A firehouse was erected on Woodbridge Avenue and was dedicated in May 1917. After the company purchased a new Mack fire truck in 1924, the weight of the truck caused the wood floor in the firehouse to sag. A concrete floor was poured and, at the same time, the firehouse was remodeled with brick facing and double doors, as seen here. The company purchased its first uniforms in 1925. (Courtesy of Ray Vliet.)

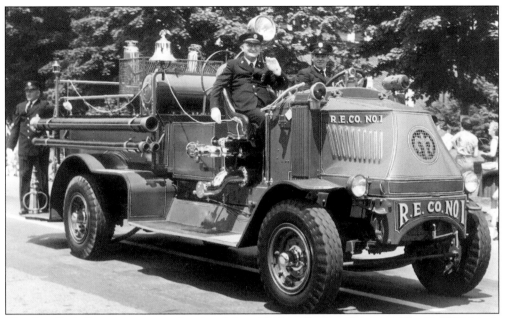

Chaplain Jack Powers waves to the crowd from Raritan Engine Company No. 1's 1924 Mack fire truck, "Old Bulldog," in the 1959 Memorial Day parade. Wendell Slavic catches a ride at the rear and Francis Coletto drives the truck. This was the first township truck to have pneumatic tires. (Courtesy of Ray Vliet.)

Raritan Engine Company No. 1 takes a moment to pose before the Memorial Day parade in 1959. Pictured, from left to right, are Wendell Slavic, Elwood Wait, Steve Varga, Frank Tachas, George Graf, Edward Monahan, John Powers, Calvin Latham, Edward Voorhees, Clifford Voorhees, and Kenny Stout. (Courtesy of Ray Vliet.)

This April 1950 photograph shows the new firemen being sworn in. Pictured, from left to right, are Ray Vliet, Carl Demko, Daniel Jordon, Richard Sheridan, Ralph Ambrosio, John Renna, and Art Tucker (municipal court clerk). (Courtesy of Ray Vliet.)

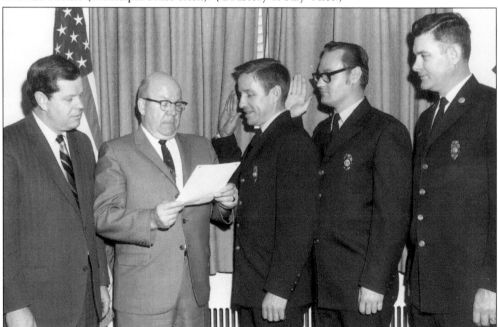

Mayor Bernard Dwyer swears in new firemen during his term as mayor (1969–1973). Pictured, from left to right, are Dwyer, Art Tucker, Richard Campbell, Lee Mazur, and Ray Vliet (fire chief). Dwyer served in the U.S. House of Representatives for 12 years and retired in 1993. He survived the attack on Pearl Harbor in 1941 while standing radio watch aboard the destroyer USS *Dale*. (Courtesy of Ray Vliet.)

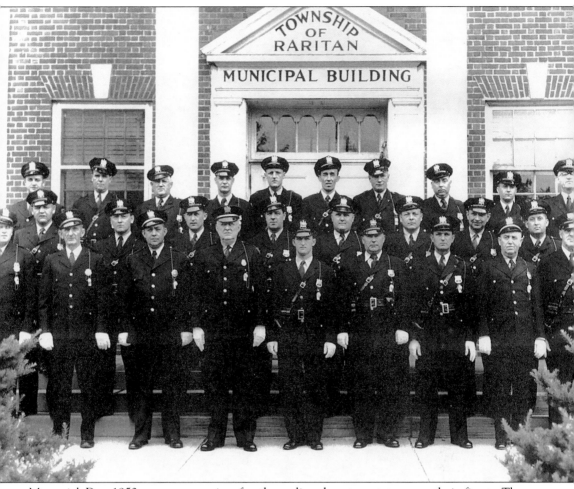

Memorial Day 1952 was an occasion for the police department to wear their finest. The ceremonies that day were in honor of the first township man killed in the Korean War, Pvt. Christian Conover. Parade Marshall Al Davis led the parade from town hall, which followed Woodbridge Avenue across U.S. Route 1, turned at Fox Road to John Street, then turned at Player Avenue, and returned to St. James Episcopal Church via Woodbridge Avenue. Pictured, from left to right, are the following: (front row) Harold Peterson, Bill Henderson, John Ellmeyer, Chas Grand-Jean, Robert Voorhees, John Calmaneri, Pete Quagliariello, Clarence Stout, and Alan Rolf; (middle row) Joe Merker, Louis Wodash, Richard McGinnes, Frank Morley, William Adams, Victor Schuster, Albert Loblein, and Steven Anthony; (back row) Joseph Smoglia, Wilbur Nelson, ? Palko, Raymond Jacobson, William Fisher, William Pinter, William Doll, T.C. Woerner, Raymond Milcsik, and ? Jacobs. (Paul Stephens.)

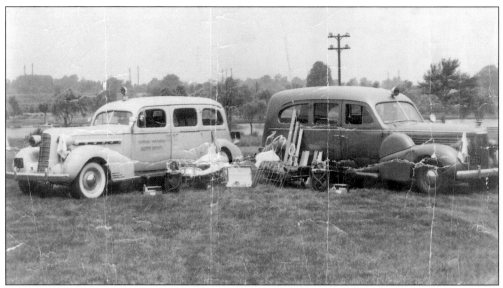

Seven township firemen formed the Raritan Township Safety Council in 1935. They purchased a used hearse and converted it into an ambulance. An ambulance, seen here, was purchased two years later. In 1937, the council purchased a La Salle ambulance, which was in use for many years. In 1949, the council was dissolved and Rescue Squad No. 1 was formed.

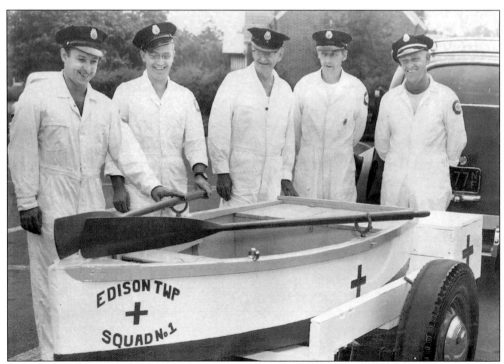

Rescue Squad No. 1 received a gift of its first rescue boat in 1952 from a New Brunswick resident who had lost a friend to drowning in East Brunswick. A second boat was purchased in the 1960s. In 1955, the squad's name was changed to the Edison First Aid and Rescue Squad No. 1 to reflect the township's name change.

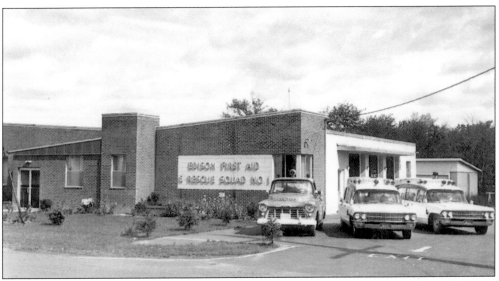

The First Aid and Rescue Squad No. 1 headquarters on Lakeview Boulevard was dedicated in 1960. The dedication ceremony included the two new Cadillac ambulances and the 1957 Chevrolet rescue truck seen here, which the squad used to aid automobile accident rescues. The squad's original home consisted of one bay at the fire department headquarters on Plainfield Avenue. A second story with a gable roof has been added to the building.

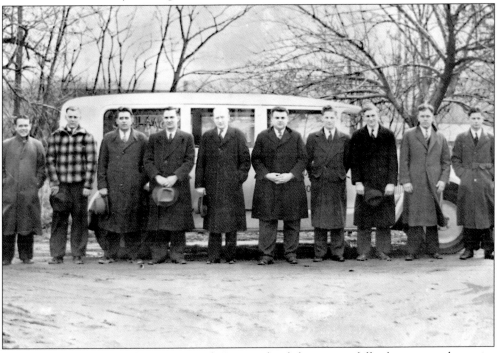

Members of First Aid and Rescue Squad No. 1 realized that it was difficult to cover the entire community and formed what is now called Edison First Aid Squad No. 2 in 1936. The 10 original squad members, in no particular order, are Thomas Swales, Joseph Ehringer, Alfred Schnebbe, Albert Christofferson, Andrew Dudas, Kenneth Shepard, Nicholas Dudas, John Hartman, Rudolph Peins, and Stewart Straka. (Courtesy of Edison First Aid Squad No. 2.)

In 1941, Edison First Aid Squad No. 2 moved into the Menlo Park Volunteer Fire Company firehouse with the fire company. Squad members are seen here inspecting blueprints for the new squad building to be built next door to the firehouse on Route 27. The new building was dedicated on August 18, 1951. (Courtesy of Edison First Aid Squad No. 2.)

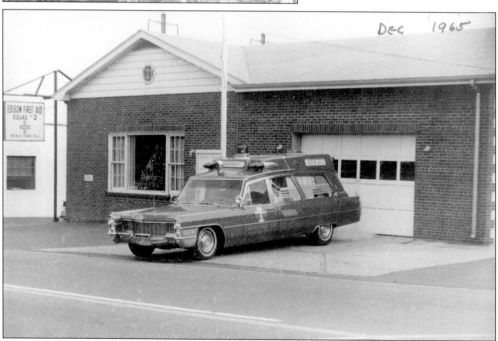

Squad No. 2's new ambulance is seen here parked in front the squad's third home in December 1965. The right-hand section was constructed in 1951. The left-hand section was constructed in 1961–1962 with donations of time and materials by local businesses. A few years later, in 1964, Squad No. 2 was under the proud leadership of a female captain, Lois Jogan. (Courtesy of Edison First Aid Squad No. 2.)

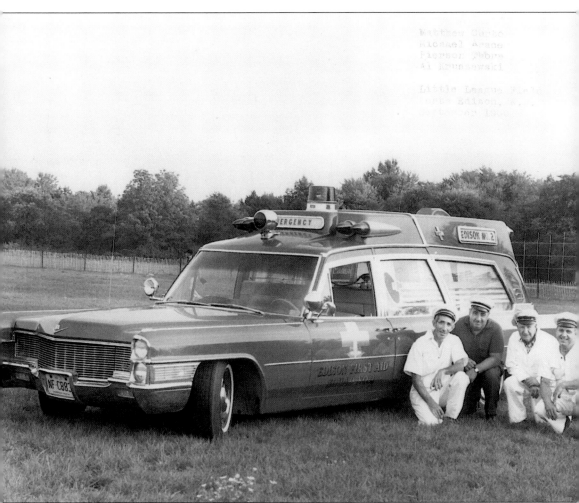

From 1936 through 1954, Squad No. 2 relied on used vehicles. The squad's first acquisition was a converted 1927 Studebaker hearse they purchased in 1936 from what is now Edison First Aid Squad No. 1. Later purchases included a 1937 La Salle ambulance in 1941 and a 1939 Buick ambulance in 1951. In 1954, a new Cadillac ambulance was purchased and, in 1965, a new $16,000 Cadillac ambulance was added to the fleet. Matthew Curto, Michael Arace, Pierson Thorp, and Al Kruszewski pose with the new ambulance on the North Edison Little League Field in September 1966. This ambulance was joined by a new modular ambulance in 1970, which, for the first time, provided the squad with two vehicles at the same time. Squad No. 2 has owned 24 vehicles during its lifetime. (Courtesy of Edison First Aid Squad No. 2.)

SELECT BIBLIOGRAPHY

Bzdak, Meredith Arms and Douglas Petersen. *Public Sculpture in New Jersey: Monuments to Collective Identity.* New Brunswick, New Jersey: Rutgers University Press, 1999. Entries for "Light Dispelling Darkness," the Thomas Edison marker on Route 27, and the Marie Curie bas-relief at the police station in Roosevelt Park.

Clayton, W. Woodford, Ed. *History of Union and Middlesex Counties, New Jersey.* Philadelphia: Everts & Peck, 1882.

Conard, C.K. *Report on the Construction of Raritan Arsenal,* 1919. On file at the Metuchen-Edison Historical Society.

Conot, Robert. *A Streak of Luck: The Life and Legend of Thomas Alva Edison.* New York: Seaview Books, 1979.

Dally, Joseph W. *Woodbridge and Vicinity: The Story of a New Jersey Township Embracing the History of Woodbridge, Piscataway, Metuchen and Contiguous Places.* 1873. Reprint. Lambertville, New Jersey: Hunterdon House, 1989.

Frasier, Marilyn and Stacy Spies. Historic American Buildings Survey for Raritan Arsenal, 1996. On file at the Metuchen-Edison Historical Society.

Heritage Studies, Inc. *Middlesex County Inventory of Historic, Cultural, and Architectural Resources.* Prepared for Middlesex County Cultural and Heritage Commission, Board of Chosen Freeholders, 1980.

Jehl, Francis. *Menlo Park Reminiscences.* Dearborn, Michigan: Thomas A. Edison Institute, 1941.

Josephson, Matthew. *Edison: A Biography.* New York: McGraw Hill, 1959.

Marshall, David Trumbull, Dr. *Boyhood Days in Old Metuchen.* 1930. Reprint. Metuchen, New Jersey: Thrifty Resource Corporation for the Metuchen-Edison Historical Society, 1999. Reminiscences of Metuchen and surrounding area during the late 19th century and early 20th century.

Sheehan, David. *Edison: An Enlightened Community.* Edison, New Jersey: Edison Township Historical Society, 1990.

Wall, John P. and Hannah E. Pickersgill, *History of Middlesex County, New Jersey, 1664–1920.* New York: Lewis Historical Publishing Company, 1921.